The 15-Minute Artist
DRAWING NATURE

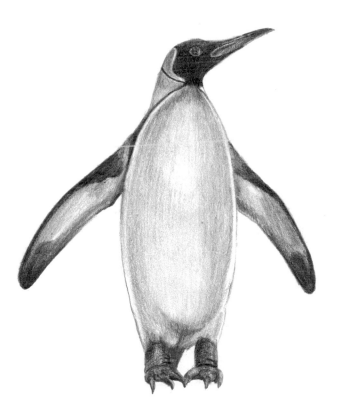

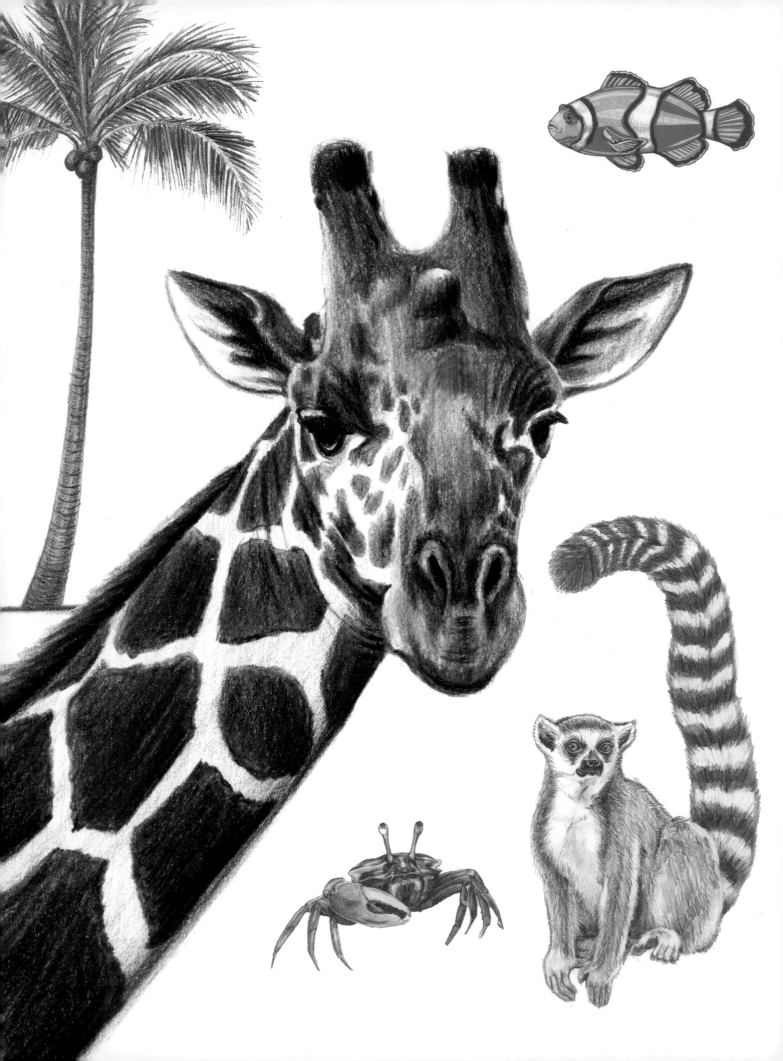

The 15-Minute Artist

DRAWING NATURE

The Quick and Easy Way to Draw Animals, Plants, and More

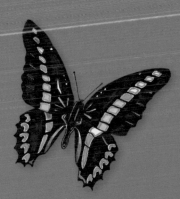

CATHERINE V. HOLMES

 Get Creative 6

NEW YORK

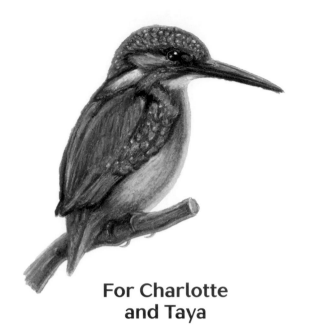

**For Charlotte
and Taya**

Get Creative 6
An imprint of Mixed Media Resources
104 West 27th Street
New York, NY 10001

Editor
LAUREN O'NEAL

Creative Director
IRENE LEDWITH

Art Director
FRANCESCA PACCHINI

Chief Executive Officer
CAROLINE KILMER

President
ART JOINNIDES

Chairman
JAY STEIN

Library of Congress Cataloging-in-Publication Data

Names: Holmes, Catherine V., author.
Title: Drawing nature : the quick and easy way to draw animals, plants, and more / Catherine Holmes.
Description: First edition. | New York, New York : Get Creative 6, a division of Mixed Media Resources, 2023. | Includes index.
Identifiers: LCCN 2023002360 | ISBN 9781684621415 (paperback)
Subjects: LCSH: Drawing--Technique. | Nature in art.
Classification: LCC NC825.N34 H65 2023 | DDC 743.6--dc23/eng/20230215
LC record available at https://lccn.loc.gov/2023002360

Manufactured in China
1 3 5 7 9 10 8 6 4 2

First Edition

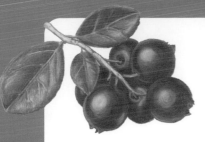

Acknowledgments

I would like to express my deepest appreciation to SoHo Publishing for making this book possible. I'm extremely grateful to Library Tales for your continued support. Words cannot express my gratitude to my family, without whom this endeavor would not have been possible.

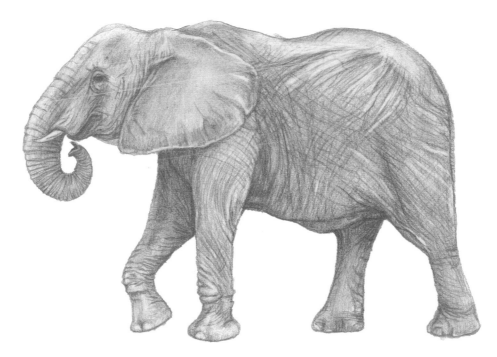

Contents

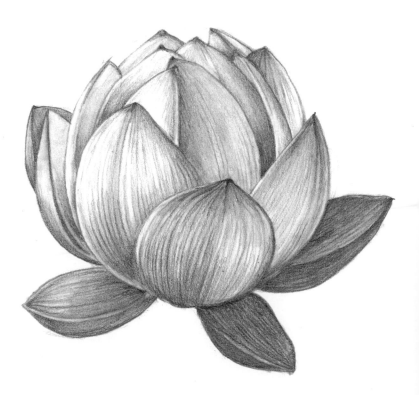

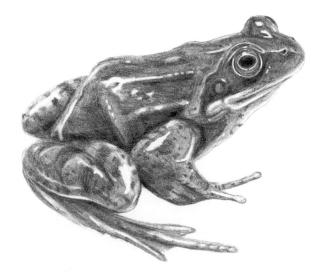

Introduction

Approachable Art

Welcome to *Drawing Nature*! Just like the other books in my 15-Minute Artist series, this book aims to make art approachable for everyone. Whether you're an old hand or just picking up a pencil for the first time, my methods will help you draw anything, from elephants to ocean waves, in just 15 minutes. You may have read the previous books in the series, *The 15-Minute Artist* and *101 Drawing Secrets*, but if you haven't, don't fret. This book contains all you need to make drawing accessible, easy, and fun.

Even for experienced artists, drawing realistic images can be intimidating. How do you get from a blank page to a final product full of detail, shading, and texture? That's where this book comes in! Each tutorial contains step-by-step instructions that walk you through the process, from simple outline to finished product.

You'll learn specific techniques like blending and hatching, but you'll also learn the general approach I and many other artists take to drawing a given subject: start with very basic

shapes and gradually add detail. After using this approach enough times on the projects in this book, you can start applying it to objects and images in your own life.

Now, that doesn't mean all your art will turn out perfect on the first try. Drawing is a skill like any other, and it requires practice. That's why I designed these projects to take 15 minutes. It's long enough to work on your skills, but short enough to fit into your schedule every day. And practicing every day is the number one way to improve as an artist over time.

Another way to improve is to draw a wide variety of subjects, and what could provide more variety than nature? In this book, you'll find a menagerie of animals, plants, and landscapes from across the entire planet. Some subjects, like hummingbirds, you might find in your backyard. Others, like platypuses, you might only see in a zoo. But all will take you on a delightful journey through the natural world, teaching you essential artistic skills along the way!

The 15-Minute Method

This is the typical process I use with most drawings, including those I demonstrate in this book.

1. Break it down into simple shapes.
2. Connect the shapes.
3. Add details.
4. Erase the initial guidelines.
5. Shade the entire object with a medium tone.
6. Darken the darkest areas.
7. Erase areas to create highlights.

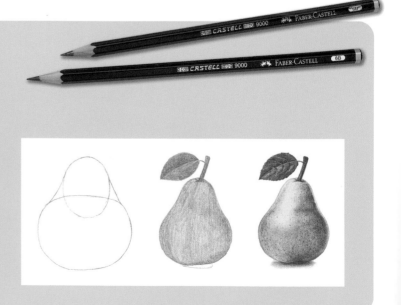

The Basics

This section explains the techniques and vocabulary that will be used throughout the book. Feel free to flip back to it if you forget what something means!

Guidelines

As you've now learned, the first step in the drawing process is to create simple shapes as a framework to build on. The lines you use to draw these shapes are called guidelines, because they *guide* what you draw next. Guidelines don't have to be precise; they just have to give you a decent idea of where to draw. They could mark the rough outlines of a shape or its approximate center—we'll do both at different points in this book. Sketch them in lightly, because you'll erase them eventually.

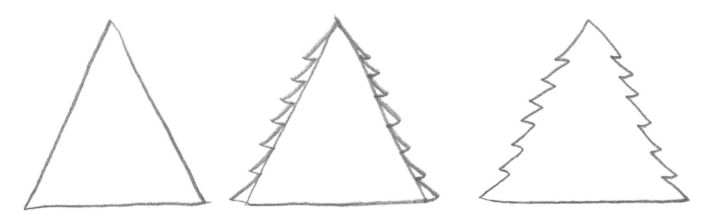

This very simplified example shows how a triangle is used as a guideline for an evergreen tree.

Tone and Shading

In drawing, we use the terms *tone* and *value* to describe how light or dark a color is, which is especially important to discuss when drawing in black and white. When I say to "add a layer of tone" or "add value," I'm talking about adding color with your pencil, even though, in this book, the color is usually a shade of gray. (In the projects that do use color, I might tell you to add *hue* instead of tone.)

The *value scale* below shows a spectrum from the lightest tones to the darkest. In the middle is the *midtone*, which represents the "true" color of whatever you're drawing. You use values lighter than the midtone for the *highlights* and values darker than the midtone for the *shadows*. The difference in value between a lighter tone and a darker tone is called *contrast*. The general process of using different tones to convey depth, shadow, and so on is called *shading*.

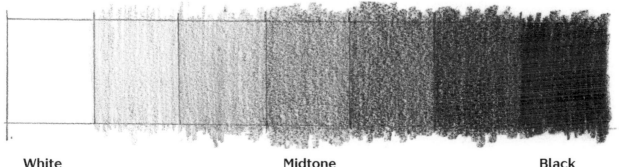

White **Midtone** **Black**

Shading in Action

Shading techniques can make any drawing look like a real three-dimensional object in an environment with light and shadow. Note the following in this drawing of a sphere.

Light source: Where the light is coming from, whether it's a lamp, the sun, etc. It's helpful to mark where the light source is in your drawing, even if only in your mind.

Highlight: The lightest area on the sphere, where the light source shines on it directly.

Midtone: The actual color or value of the sphere.

Core shadow: The darkest area on the sphere.

Reflected light: A lighter area on the side of the sphere facing away from the light source, created by light reflecting back from the surface the sphere is sitting on.

Cast shadow: The shadow the sphere casts on the surface it's sitting on. The length of the cast shadow depends on the position of

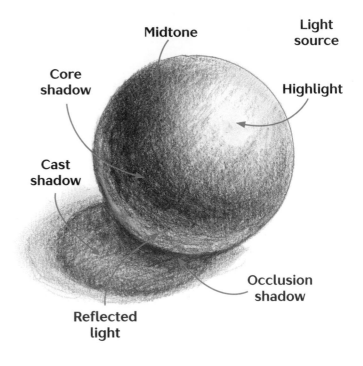

the light source (it's shorter the more directly overhead the light source is).

Occlusion shadow: The darkest area of the cast shadow, which is close to the sphere.

Shading Techniques

These techniques help convey different textures and make a drawing come convincingly to life.

Hatching uses closely spaced parallel lines. The closer together they are, the darker the shading appears. This technique is great for fur and feathers, as you'll see in this book.

Cross-hatching uses two layers of hatching, with the second layer perpendicular to the first one.

Stippling uses lots of small dots. As with hatching, the closer together they are, the darker the shading appears.

Scumbling uses lots of tiny, overlapping circles. Lighter pressure and larger circles result in a rougher-looking texture, while harder pressure and smaller circles look smoother. For best results, use a sharp pencil. It may help to pretend you're drawing a Brillo pad.

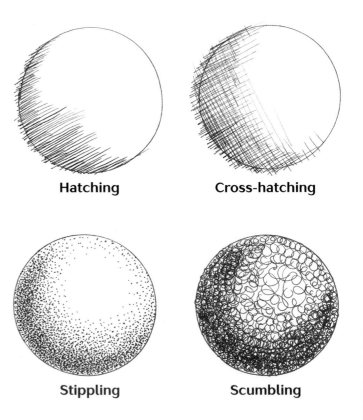

Hatching

Cross-hatching

Stippling

Scumbling

Cross Contours

Cross contours are lines (drawn or implied) that travel across a form—like this vase. They may be horizontal, vertical, or both, but they always follow the three-dimensional shape of an object or surface. Somewhat counterintuitively, they get closer to each other the farther they are from the viewer, and farther apart from each other the closer they are to the viewer. Even though you usually don't actually draw the cross-contour lines, your pencil strokes and shading should always follow them for maximum realism.

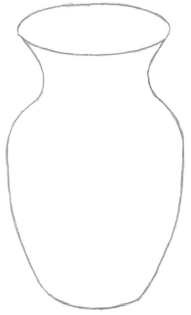 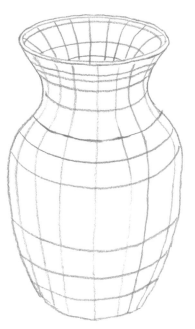 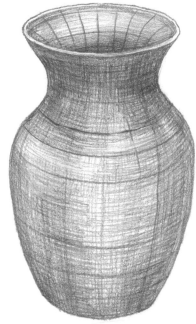

1. Outline of vase (no cross contours)

2. Vase with cross contours drawn

3. Vase shaded along cross contours

Blending

Blending is the technique of creating a gradual transition from one value to another. It's crucial when drawing in pencil, and we'll use it in virtually every project in this book.

How do you blend? Gently rub the blending tool of your choice back and forth over the tones a few times to smooth them together. Don't overblend, or you'll smooth all your contrast into one gray tone. (If you do, don't worry—just add another layer of graphite where the tone should be darker.) For best results, follow cross contours while blending.

Before blending

After blending

With highlights added

Art Materials

These are the art materials you'll want to have on hand—first the need-to-haves, followed by the nice-to-haves. All are easy to find online or in any art supply store.

The Essentials

You'll need these drawing tools for almost every tutorial in this book (and most drawing projects you do outside of this book, as well).

Pencils: Though you can technically use a regular #2 pencil, I recommend getting a set of artist pencils. (Many are quite affordable!) These pencils come in "H" (hard) and "B" (soft). H has harder graphite, which leaves lighter, thinner marks and can be sharpened to a very fine tip. B has softer graphite, which leaves darker, thicker, smudgier marks. Each pencil also has a number grade. The higher the number, the lighter (for H) or darker (for B) the pencil will be. My default is a 6B.

Paper: Cheap printer paper will make it harder to blend shades, resulting in less attractive art (and increased frustration). You don't need to break the bank, but grab a pad of dedicated drawing paper. A medium "tooth" (roughness) works best for pencil.

Kneaded eraser: Kneaded erasers can be molded into any shape and don't leave crumbs behind like regular erasers. They're a must for the kind of precision erasing necessary for creating highlights.

Blending tools: You can use specialty tools like a blending stump, tortillon, or kneaded eraser. You can use household items like a tissue, cotton swab, chamois cloth, dry paintbrush, or even your finger. But you'll definitely need something to blend with.

Kneaded eraser

Blending stump

Tortillon

Other Art Materials

Most of the projects in this book just use regular drawing pencils, but there are a few fun forays into other art materials. If you only get one of the tools below, I'd recommend colored pencils. They're used the most often in this book and will likely be most useful to you outside it.

Colored pencils: Oil-based colored pencils labeled "professional" or "artist" are often higher-end than those that are wax-based or labeled "student," but there's no need to drop a lot of money if you don't want to. Aim for a set of 36 or 48 to get a wide variety of colors.

Markers: Any brand of fine-point permanent markers will do. Personally, I like Sharpies.

Fine-tip pen: Once again, any brand of pen with an ultrafine tip will do. (And once again, I personally like Sharpies!)

Oil pastels: Also called oil wax crayons, these are sticks of pigment combined with oil and wax binder. (Don't use your finger to blend, unless you want to get messy.) Oil pastels never dry completely, so protect your drawing with glassine or a frame. If possible, use a rougher paper than you use for pencil drawings.

Chalk pastels: Also called French pastels, these are similar to oil pastels but softer and chalkier. They also work better with rougher drawing paper, if you have it.

Watercolor pencils: These are a special type of colored pencil made with a water-soluble binder. After you use them, you apply a layer of water with a paintbrush to activate the colors.

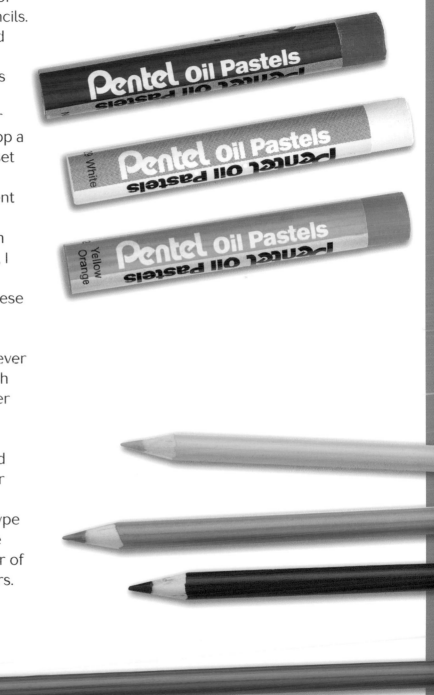

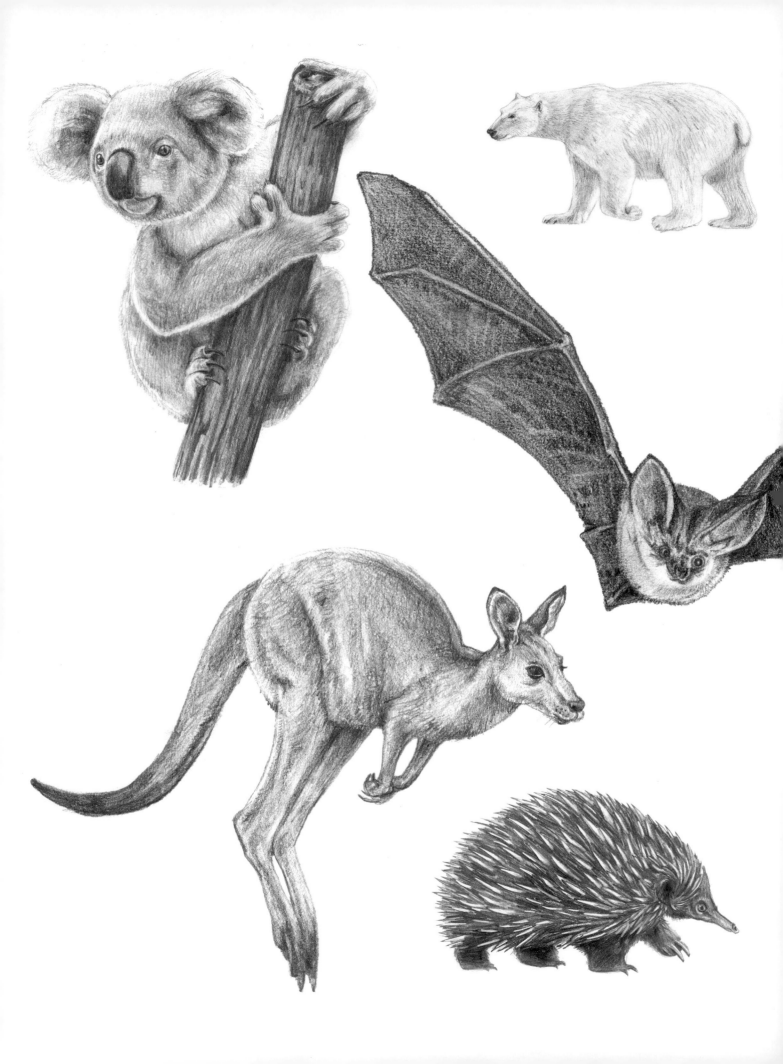

Chapter 1
FURRY FRIENDS

We'll start our journey through the natural world with a chapter on drawing mammals in many different shapes and sizes. You'll learn how to convincingly create all kinds of fur and hides, from fuzzy to spiny and everything in between. Just follow the simple steps to draw a red panda cute enough to cuddle—or a frighteningly ferocious jaguar!

ELEPHANT

Weighing up to 11 tons, elephants are the largest land mammals on earth. They're also a great way to learn about drawing with cross contours, the visible or imaginary lines that travel across any form (see page 11).

1 Start with three overlapping circles that get progressively get larger. (You can think of this as a sideways snowman.)

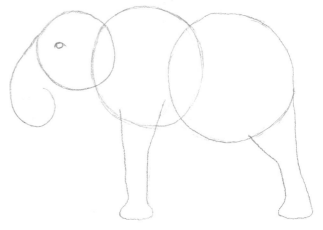

2 Add the left front and rear legs, an eye, and a curl for the trunk.

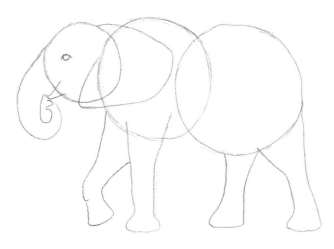

3 Add the right front and rear legs, a triangular ear, and a mouth. Finish the trunk.

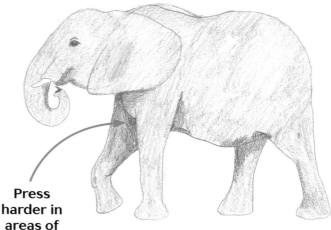

Press harder in areas of shadow.

ADD TONE

4 Erase guidelines that are no longer needed. Refine the body shape and add a tusk. Add a light layer of tone over the entire elephant.

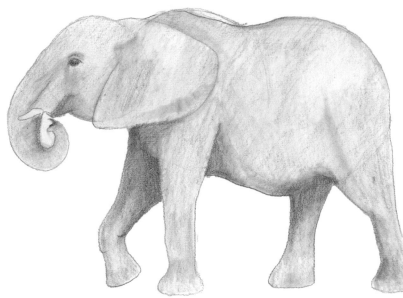

5 Smooth the tones with a blending tool.

FOLLOW CROSS CONTOURS

6 Add deep lines for wrinkles that follow the cross contours of the body. Add more tone to deepen shadows.

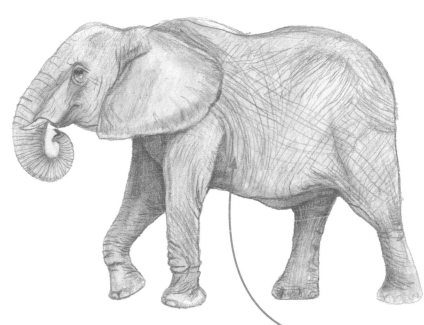

Wrinkles and shading make cross contours visible.

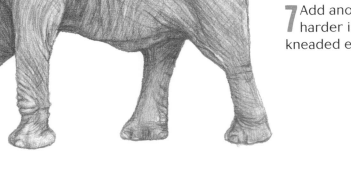

7 Add another layer of tone, pressing harder in darker areas. Use a kneaded eraser to create highlights.

SQUIRREL MONKEY

Much like their namesake, these South American monkeys are small and gray, with long tails that help them balance as they climb trees. Use hatch marks to replicate the fuzzy texture of their fur.

1 Start with overlapping ovals for the head and body. Add guidelines for the tail and legs.

Add finger guidelines.

2 Add facial details, finish the tail, and thicken the legs.

Thicken fingers.

BLOCK IN TONE

3 Add a layer of tone to block in the major forms.

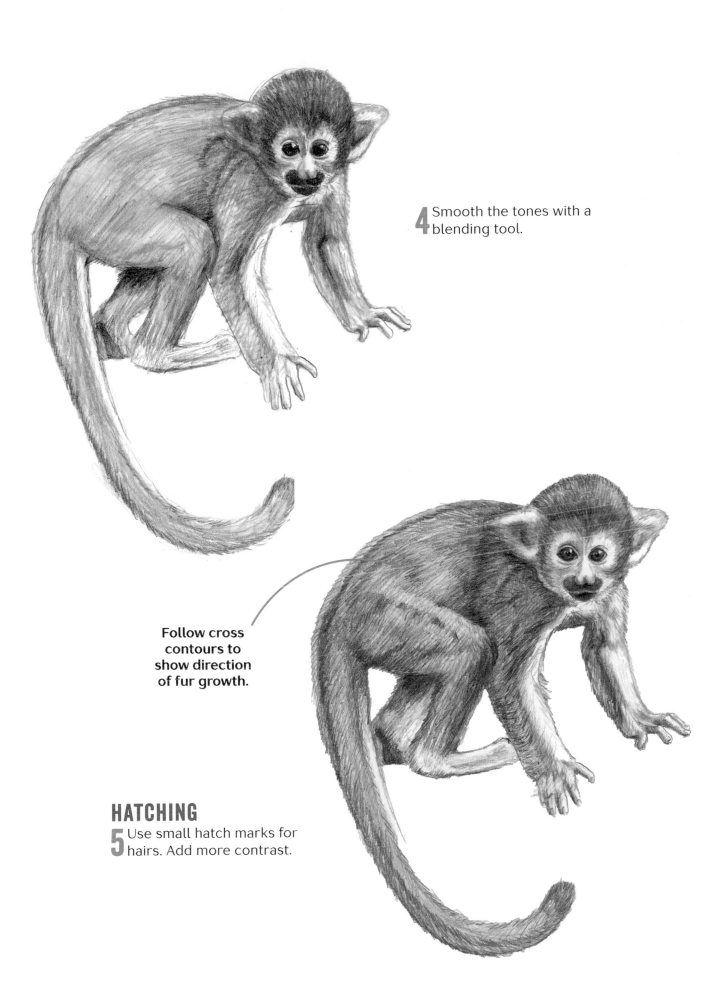

4 Smooth the tones with a blending tool.

Follow cross contours to show direction of fur growth.

HATCHING

5 Use small hatch marks for hairs. Add more contrast.

ZEBRA

Sometimes things aren't so black and white, even with zebras. Let's learn about the subtleties of contrast by drawing one.

BASIC SHAPES

1 Start with circular shapes for the chest and rear, leaving a generous space between the two. Add a small circle for the head and guidelines for the legs.

Head turned slightly toward viewer

2 Connect the chest and rear with curved lines. Thicken the left front and rear legs. Add a snout and a guideline for the tail.

3 Add shapes for the mane, eye, and ears. Add the right front and rear legs.

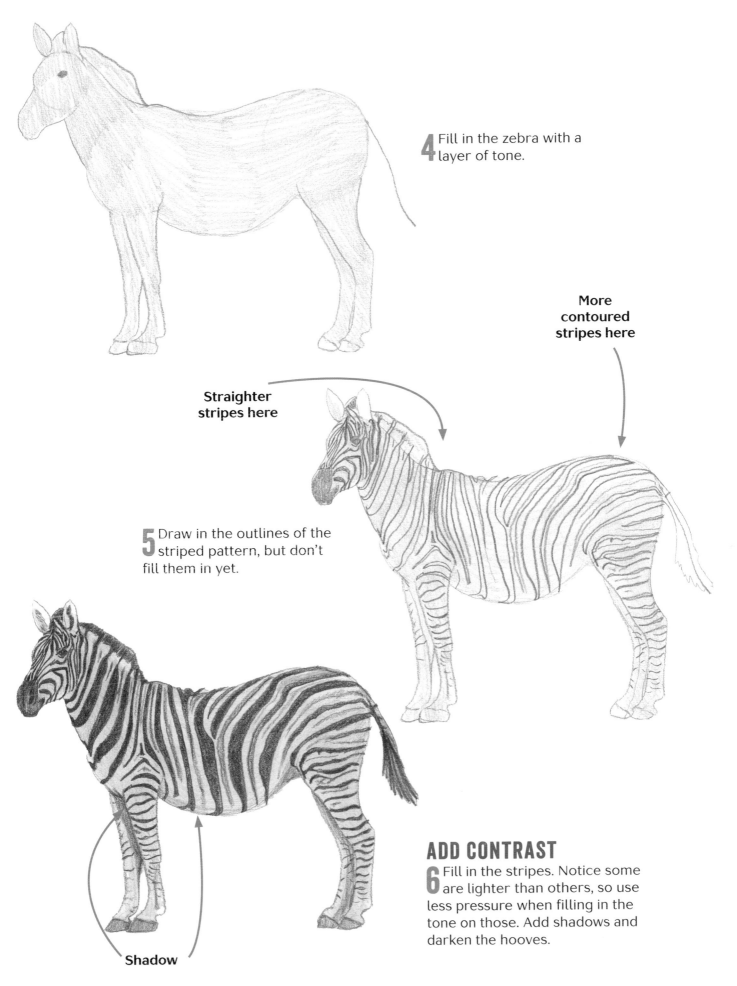

4 Fill in the zebra with a layer of tone.

More contoured stripes here

Straighter stripes here

5 Draw in the outlines of the striped pattern, but don't fill them in yet.

ADD CONTRAST

6 Fill in the stripes. Notice some are lighter than others, so use less pressure when filling in the tone on those. Add shadows and darken the hooves.

Shadow

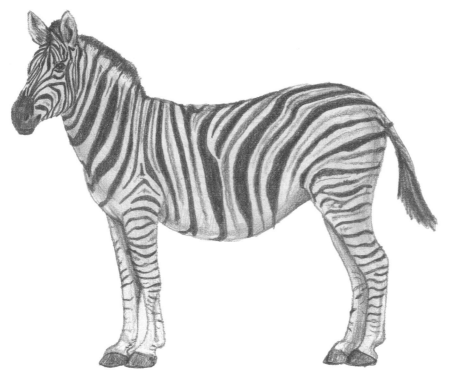

DEEPEN CONTRAST

7 Add hairs to the mane and ears. Darken the nose and stripes. Add shadow to the neck, lower body, and hooves.

DEEPEN CONTRAST MORE

8 Use a kneaded eraser to highlight areas of lightness. Deepen shadows for contrast if necessary.

QUICK TIP

Just press the kneaded eraser a bit to pull up some of the pigment.

SLOTH

Sloths can sleep for 15 hours a day...but they only take 15 minutes to draw! This lesson will show you how to use a needle or paper clip to subtly replicate the coarse texture of sloth fur.

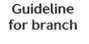

Guideline for branch

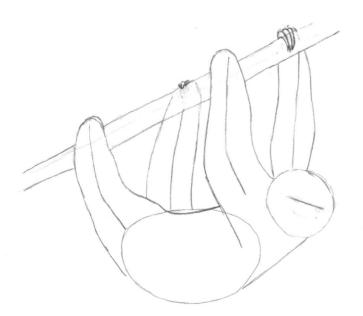

BASIC SHAPES

1 Start with a circle for the head, an oval for the body, and lines to indicate where the legs will go.

2 Add thickness to the legs. Draw a line connecting the head to the body.

REFINE THE SHAPE

3 Add claws, a belly line, a branch, and a guideline for eye placement.

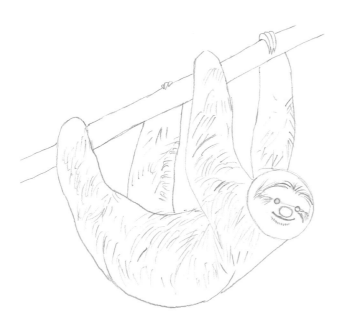

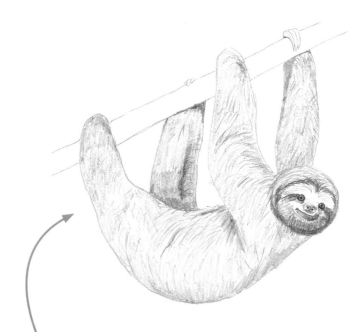

4 Add facial details. Draw sparse lines all over the body to indicate fur texture.

Scratch lines may not be very visible yet.

5 Draw more fur lines with a needle or paper clip, then switch back to a pencil to add a layer of tone all over the sloth. Add more facial details.

Needle Scratch

To create white or light strands of fur, draw a line with the tip of a needle or the edge of a paper clip, pressing down hard enough to indent (but not rip) the paper. When you apply tone over it, the indent will remain lighter than the surrounding tone.

ADD TEXTURE

6 Using a hard pencil (such as an H), make more individual fur lines. Add another layer of tone and darken areas of shadow for more contrast.

Tone follows direction of fur.

7 Add more fur. Darken shadow areas more.

QUICK TIP
Too much blending will take away the contrast from the tones, making the scratch lines look too intense by comparison.

BLEND AND HIGHLIGHT

8 Lightly and carefully blend the tones, barely smoothing them. Use a kneaded eraser to highlight and lighten areas of lightness. Add back any darker tones that were smoothed away.

KOALA

Draw this cuddly koala by using scumbling—a shading technique achieved by overlapping lots of little circles—to create a soft, furry texture.

ADD DETAILS

2 Add basic facial features, arms, feet, and a tree branch. To keep the paws simple for now, use a mitten shape and add lines to mark where the fingers will go.

SIMPLE SHAPES

1 Start with a small circle for the head and an overlapping oval shape for the body.

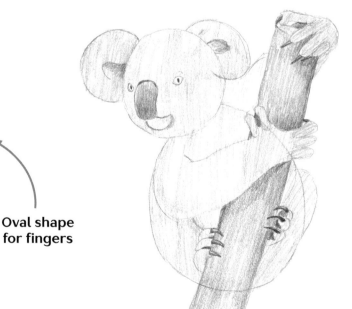

Oval shape for fingers

3 Add the chin detail as well as individual fingers. Add claws.

BASIC SHADING

4 Add a light layer of tone to the entire koala. The nose, claws, inner ears, and tree branch can be a bit darker than the rest.

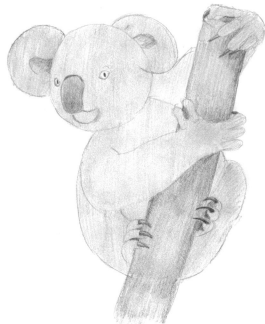

QUICK TIP
Use a zigzag motion to draw the fur quickly.

5 Using a blending tool or finger, gently blend the tones together to smooth them out.

6 Erase any unnecessary guidelines. (Things in real life aren't outlined, so your drawing shouldn't be either!) Add fur lines to indicate the direction of fur growth following cross contours.

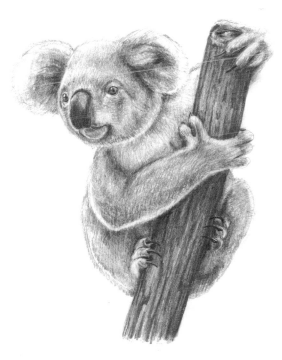

Scumbling

The texture you create with scumbling is determined by the size of the circles and the pressure used on the pencil. Scumbling can also be created with more scribbly, "spidery" lines rather than neat little circles.

7 To make a fuzzy, softer texture, add scumbling over the drawing. Add more tone and smooth with a blending tool.

JAGUAR

The jaguar is a fearsome predator. Getting the contrast in the facial wrinkles right is key to making this jaguar's snarl convincingly ferocious.

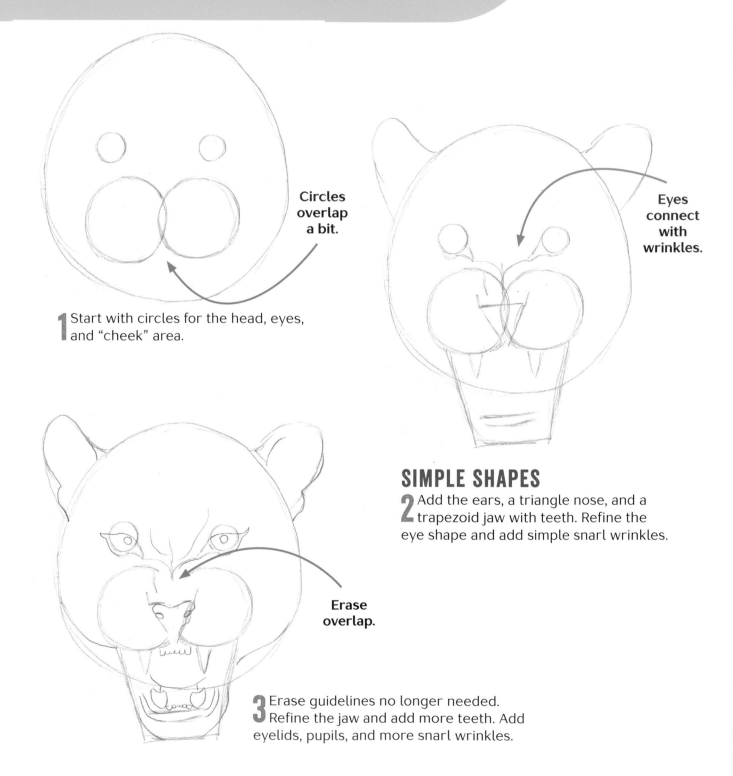

Circles overlap a bit.

1 Start with circles for the head, eyes, and "cheek" area.

Eyes connect with wrinkles.

SIMPLE SHAPES

2 Add the ears, a triangle nose, and a trapezoid jaw with teeth. Refine the eye shape and add simple snarl wrinkles.

Erase overlap.

3 Erase guidelines no longer needed. Refine the jaw and add more teeth. Add eyelids, pupils, and more snarl wrinkles.

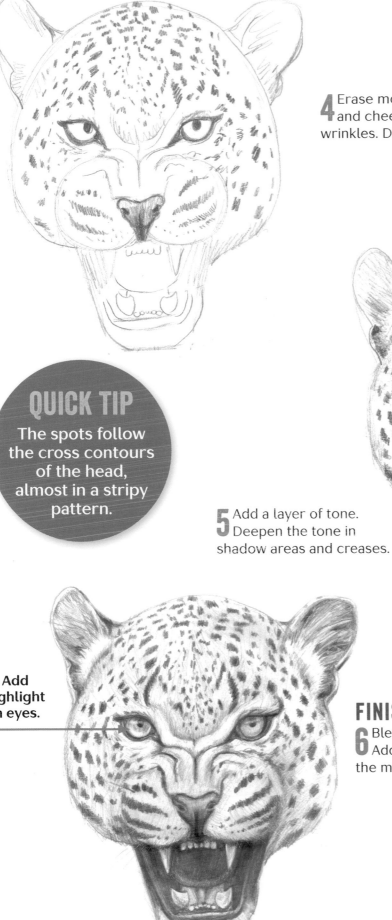

4 Erase more guidelines in the mouth and cheeks. Add spots, stripes, and wrinkles. Darken the outline of the eyes.

QUICK TIP

The spots follow the cross contours of the head, almost in a stripy pattern.

5 Add a layer of tone. Deepen the tone in shadow areas and creases.

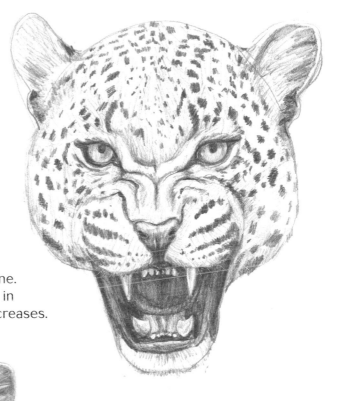

Add highlight in eyes.

FINISHING TOUCHES

6 Blend the tones with a blending tool. Add contrast to the spots and darken the mouth. Define the eyes.

BAT

Bats are the only mammals that can fly! Here we'll use an eraser as a drawing tool to capture the leathery texture of their wings.

BASIC SHAPES

1 Start with a circle shape for the head and guidelines for the wings.

2 Add ears, a snout, and curved lines for the bottoms of the wings.

Erase guidelines.

3 Add eyes, a nose, and the bones in the wings. Add a layer of tone.

ADD TONE

4 Deepen the tone in darker areas. Add lines for fur texture around the face.

QUICK TIP

Blocking in your drawing with a layer of tone obscures the paper's color so you can visualize the final image better.

5 Smooth the tones with a blending tool. Use an eraser to highlight patterns, veins, and bones in the wings.

Add more tone to shadows for contrast.

GIANT PANDA

What could be cuter than a roly-poly panda? Recreate their iconic black-and-white look by using contrast.

CIRCLES

1 Start with a large circle for the head, a smaller circle for the snout, and small circles for the eyes.

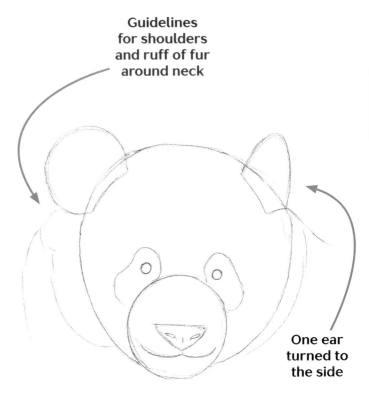

Guidelines for shoulders and ruff of fur around neck

One ear turned to the side

ADD DETAILS

2 Add rounded ear shapes, a triangle shape for the nose, a curved mouth, and oval shapes around the eyes.

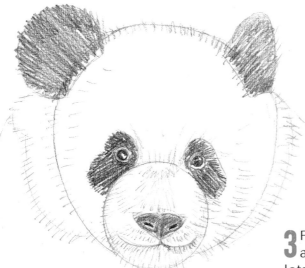

3 Fill in the ears, nose, and dark circles around the eyes to block them in. Add lots of individual hairs.

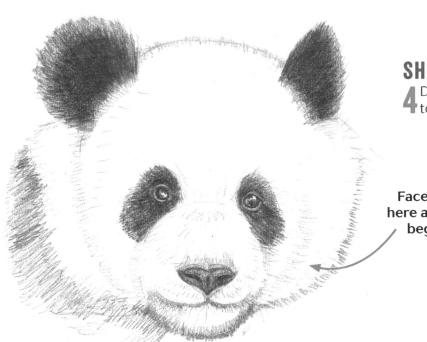

SHADE

4 Darken the areas of black fur and add tone for a few shadows.

Face ends here and ruff begins.

5 Refine the nose with highlights and shadows. Use a zigzag motion to darken the ears. Darken under the chin. Draw lots of small lines for hairs on the chin.

Hair follows cross contours of face.

QUICK TIP

Use a 2B pencil (finer than a 6B) for the fine hairs above the nose.

GIRAFFE

Topping out at 18 feet tall, giraffes are the tallest living animals. Practice using colored pencils and drawing patterns with this gentle giant.

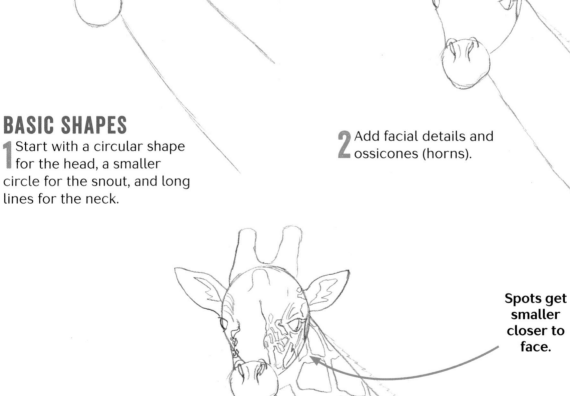

BASIC SHAPES

1 Start with a circular shape for the head, a smaller circle for the snout, and long lines for the neck.

2 Add facial details and ossicones (horns).

Spots get smaller closer to face.

3 Add the coat pattern.

ADD COLOR

4 Erase guidelines that are no longer needed. Using the giraffe's basic hues (light brown, brown, and black), fill in the pattern on the face and neck.

Leave the lightest areas white for now.

COLOR AND SHADING

5 Add another layer of color, deepening the areas of shadow. Add a bit of light blue to the shadows and a bit of yellow to the light areas.

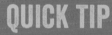

QUICK TIP

Add a little light brown over the cool light blue areas to warm it up.

Black at mane crest

Deepen wrinkle lines with dark brown.

6 Press hard with medium brown as a blender to smooth the tones inside the pattern. Rim the darkest edges with a thin layer of black. Blend out the lighter pattern areas with light brown, pressing hard to cover all the paper.

BROWN RAT

Some people consider rats pests; others consider them pets. Either way, they're fun to draw!

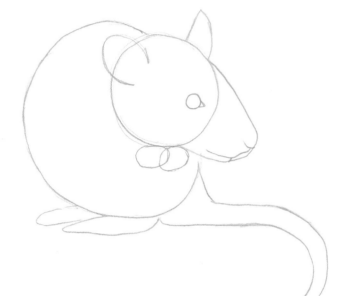

1 Start with a small circle for the head. Draw a larger circle around it for the body. Add a tiny circle eye and curved ears.

ADD DETAIL

2 Draw a snout, a small triangle at the eye, small overlapping circles for front paws, two longish ovals for back feet, and a long, thick, curvy tail.

MORE DETAIL

3 Erase guidelines. Sketch in the toes and the shape of the white pattern in the belly fur.

4 Darken the eye. Add a layer of tone to block in different areas.

Use tone to hint at shape of elbow.

QUICK TIP
Always move your pencil in the direction of the fur growth.

5 Add another layer of tone, darkening where shadows and deeper hues are. Keep following the cross contours of the body and fur growth. Add nails to the toes.

Whiskers and dots

FINISHING TOUCHES

6 Add more shading to the face and body to create contrast. Add short lines around the edges for a soft fur look. Add the pattern to the tail.

PLATYPUS

In this tutorial, we'll use blending to replicate the texture of the platypus's dense, waterproof fur.

1 Start with an oval body, a circular head, and curves for the tail and iconic "duck bill."

Slightly convex

Slightly concave

BASIC OUTLINE
2 Add the feet and the rest of the bill. Refine the body shape.

Shadows on ridges of bill

3 Add claws and a layer of tone.

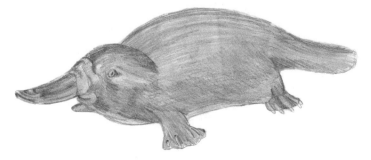

BLEND ONCE
4 Blend the tones to smooth them.

5 Add another layer of tone, this time using hatch marks (short lines) to indicate fur texture.

6 Add more fur texture. Add contrast using heavy pencil pressure.

BLEND AGAIN

7 Smooth the tones to blur and blend so every little hair doesn't stand out. Use a kneaded eraser to make highlights.

ECHIDNA

Also called the spiny anteater, the echidna is covered in quills. Using contrast when drawing those quills makes them look more realistic.

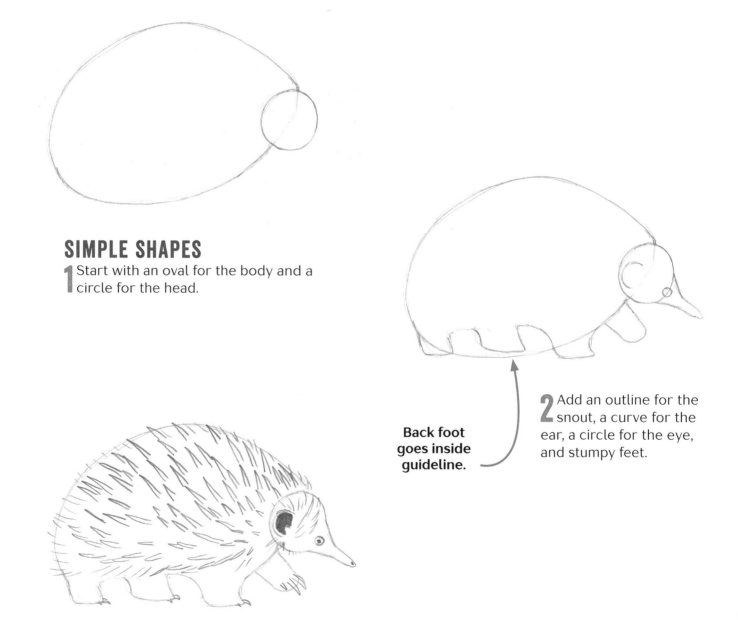

SIMPLE SHAPES

1 Start with an oval for the body and a circle for the head.

2 Add an outline for the snout, a curve for the ear, a circle for the eye, and stumpy feet.

Back foot goes inside guideline.

3 Erase the guidelines. Add claws and some facial details. Draw some of the main quills.

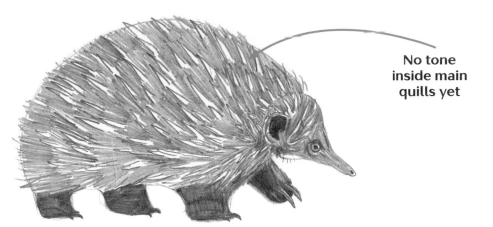

No tone
inside main
quills yet

ADD TONE

4 Add more spikes and a layer of tone to block in shapes.

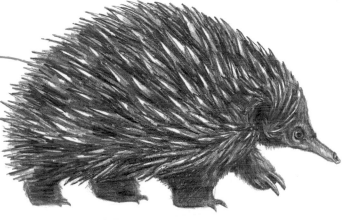

Tone at base
of quill but
not tip

ADD MORE TONE

5 Use more pencil pressure to create more contrast in the darker crevices between the quills. Add tone to create depth on the face and darken the feet.

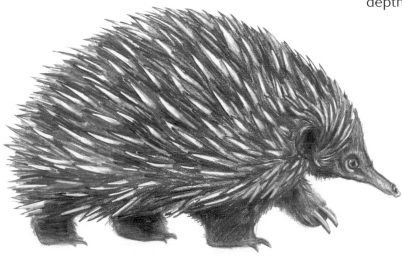

6 Use a kneaded eraser to make the spikes and highlights even lighter.

Close-Up: Quill

Notice the variation in tone from the base of the quill to the tip.

RED PANDA

Despite its name, the red panda is more closely related to the skunk than to the giant panda. Contrast is important for capturing the charming patterns on its face and tail.

1 Start with a curve for the back. Add a circle for the head, two small circles for the eyes, and a wide U shape for the snout.

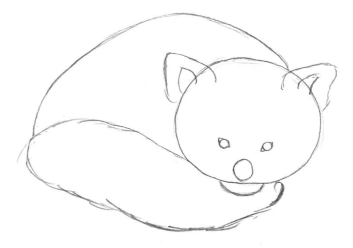

BASIC OUTLINE
2 Refine the eye shape. Add ears, a circle for the nose, and a curve for the tail.

Use heavier pressure for darker tones.

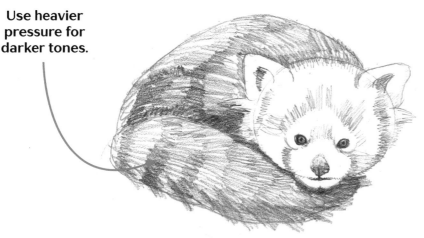

ADD TONE
3 Add a layer of tone, using a back-and-forth motion to mimic the fur's texture.

ADD MORE TONE

4 Blend to smooth tones. Add another layer of tone, darkening the darks and keeping the lights light.

QUICK TIP
Draw using zigzag or hatch marks to replicate fur texture.

Add lines for fur around edges as needed.

5 Soften the edges by pressing with a kneaded eraser. Use an eraser to lighten highlights and draw individual white hairs.

Whiskers and dots

CAPYBARA

The capybara is the largest rodent in the world. Adding multiple rounds of highlights and darker tones produces contrast that brings the texture of the capybara's hair to life.

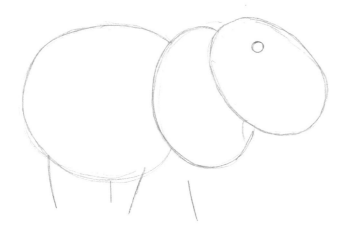

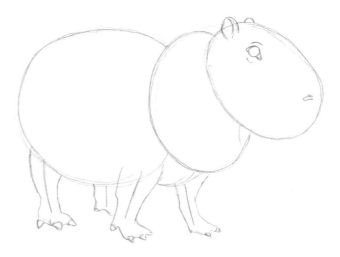

BASIC SHAPES

1 Start with an oval for the head, a circle for the eye, an oval for the chest, a wide oval for the belly, and lines as guides for the legs.

2 Refine the eye shape. Add ears, a nostril, and legs.

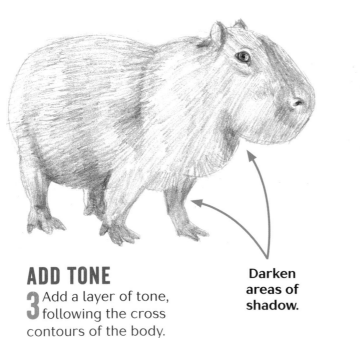

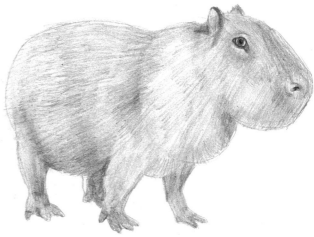

ADD TONE

3 Add a layer of tone, following the cross contours of the body.

Darken areas of shadow.

4 Smooth the tones with a blending tool.

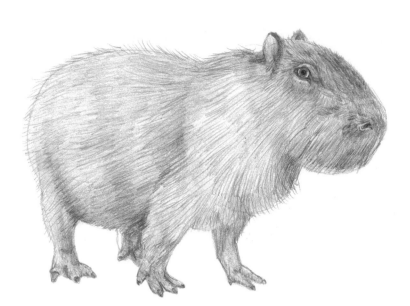

5 Use a zigzag motion to add hairs following the cross contours of the body.

Dark rim around eye

ADD CONTRAST
6 Darken shadow spots. Erase individual tufts of hair to highlight them.

Whiskers and dots

Erase spot in eye to form highlight.

ADD MORE CONTRAST
7 Use a kneaded eraser to highlight more hairs and shiny spots. Darken feet and shadow spots more. Blend as needed.

KANGAROO

Kangaroos are icons of the Australian outback. Keep adding tone, offset with highlights, to create depth and texture on this leaping marsupial.

SIMPLE SHAPES

1 Start with a large circular shape for the body, a smaller circle for the head, and a long line for the tail. Connect the head and body with a line for the neck.

2 Add guidelines to indicate the position of the legs. Thicken the neck and tail. Add ears and a snout.

3 Add facial features and ear details. Erase the tail and neck guidelines. Thicken the legs.

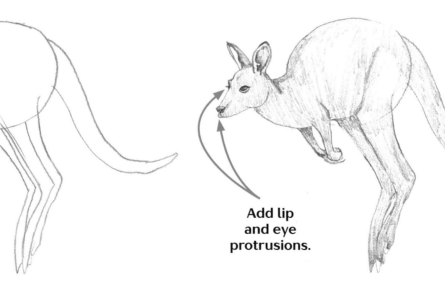

Add lip and eye protrusions.

ADD TONE

4 Erase the guidelines. Refine the paw shape. Add a light layer of tone over the entire kangaroo.

MORE TONE

5 Deepen areas of shadow with darker tone. Add short lines to indicate fur texture.

QUICK TIP
Press harder in areas of shadow, and leave the lightest areas white.

6 Use a blending tool to smooth the tones. Erase areas of highlight that may have become darkened with blending. Go over some of the fur lines with a hard pencil to define them.

Dab with a kneaded eraser to lighten.

POLAR BEAR

Technically, a polar bear's fur isn't white—it's transparent. And the key to drawing that fur isn't to leave white space on the page but rather to use light tone that contrasts with areas of shadow.

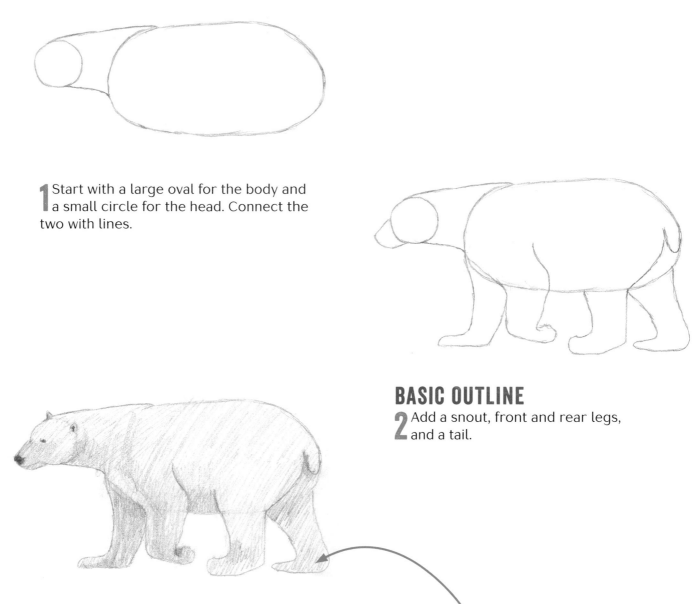

1 Start with a large oval for the body and a small circle for the head. Connect the two with lines.

BASIC OUTLINE
2 Add a snout, front and rear legs, and a tail.

3 Add facial features. Erase the guidelines. Add a very light layer of tone over the entire bear.

Slightly darker tone in shadow areas

TONE AND TEXTURE

4 Add more tone with short lines to indicate fur, drawing the lines in the direction the fur grows.

Denser fur in areas of shadow

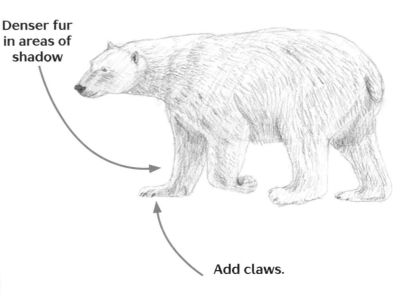

Add claws.

QUICK TIP

Erase any outlines that may create too sharp a contrast.

BLEND AND HIGHLIGHT

5 Refine the facial features. Smooth the tones with a blending tool. Use a kneaded eraser to remove areas of pigment on highlighted spots.

HIPPOPOTAMUS

Hippos spend most of their time partially submerged in rivers and lakes. Learn how to draw an image reflected in water with this hippopotamus tutorial.

BASIC SHAPES

1 Start with a half-circle for the skull, a circle for the eye, and curved lines for the back and snout.

2 Add the nostril, eye, and ear details. Start adding reflections to the area below the head. This will be the surface of the water.

3 Erase guidelines. Add a light layer of tone, including in the reflection. Use a darker tone for shadows.

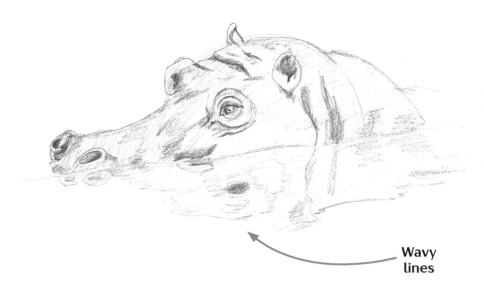

Wavy lines

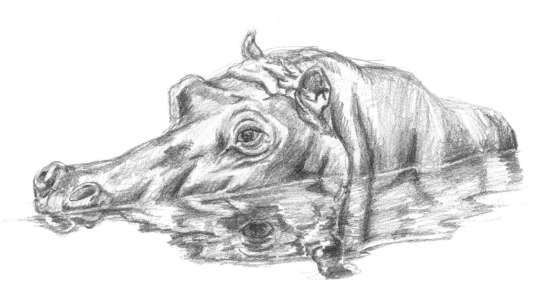

SHADING AND CONTRAST

4 Deepen the tone in darker areas, particularly wrinkles and facial details, by pressing harder with your pencil. Add another layer of tone to deepen the whole image.

QUICK TIP

The lines in the reflection should mirror the hippo closely, but they don't need to be exact, because the surface of the water isn't perfectly still.

5 Darken more. Smooth the tones with a blending tool. Use zigzag lines in the water so it appears to have ripples.

Wrinkles are darker in reflection too.

QUOKKA

Native to Australia, the quokka is a marsupial like koalas and kangaroos. Use hatch marks and cross contours to draw this teddy bear–like creature.

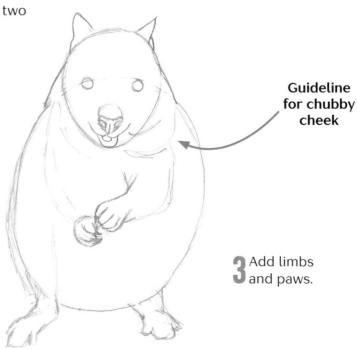

BASIC SHAPES

1 Start with a large round base, a smaller egg-shaped head, and eyes along the line where the two shapes intersect.

ADD DETAILS

2 Add the nose and mouth. Add triangle-shaped ears and refine the head shape.

Make head bulkier.

Guideline for chubby cheek

3 Add limbs and paws.

Guideline for chubby cheek

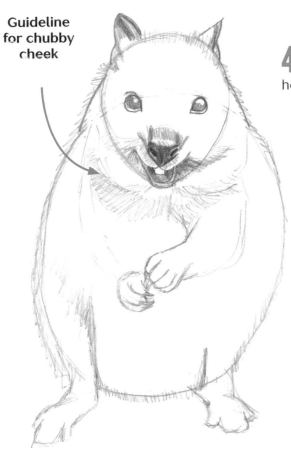

4 Start shading the face area. Add some hatch marks around the head and face for fur.

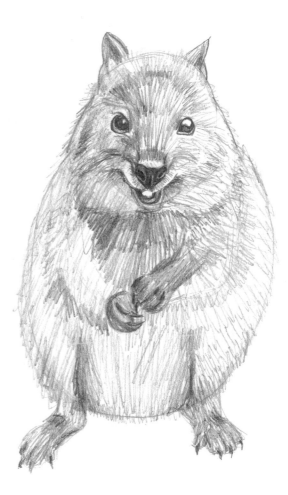

ADD TONE

5 Fill in with tone, using a back-and-forth motion that follows the cross contours of the fur. Add claws.

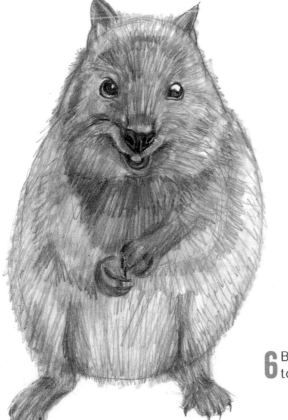

6 Blend the tones.

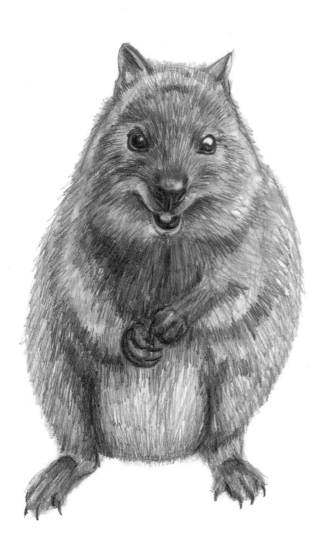

7 Add individual hairs using hatch marks. Use more pressure for darker areas.

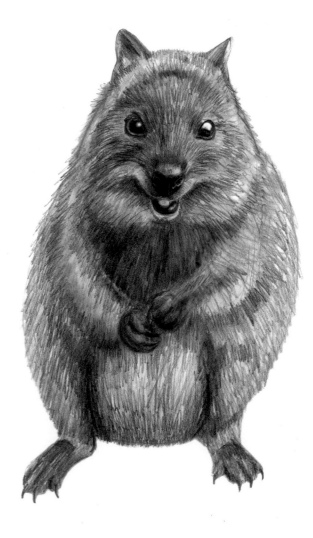

DEEPEN CONTRAST
8 Deepen the tones even further to create contrast. Smooth the tones to blur them a bit.

LEMUR

We'll use a pop of color for this ring-tailed lemur's eyes, creating a focal point that balances out the dramatic contrast of the striped tail. Don't overblend in the last step!

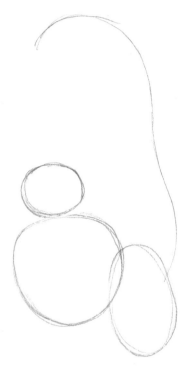

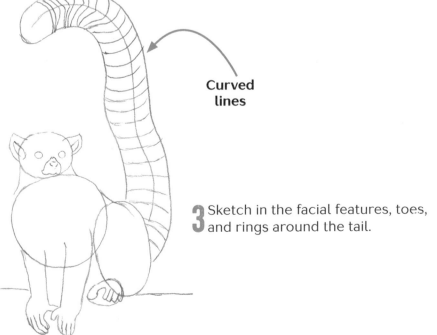

QUICK TIP

Use a mitten shape for the hand, or simplify it even further by making it a small, rounded shape.

2 Add legs, paws, a tail, and a line for a tree branch. Draw lines to connect the shapes.

BASIC SHAPES

1 Start with a small circle for the head, a large circle for the body, an oval for the hind leg, and a line for a tail.

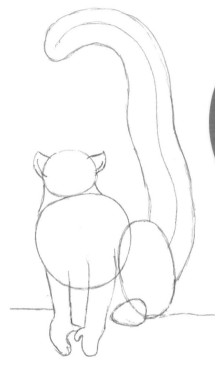

Curved lines

3 Sketch in the facial features, toes, and rings around the tail.

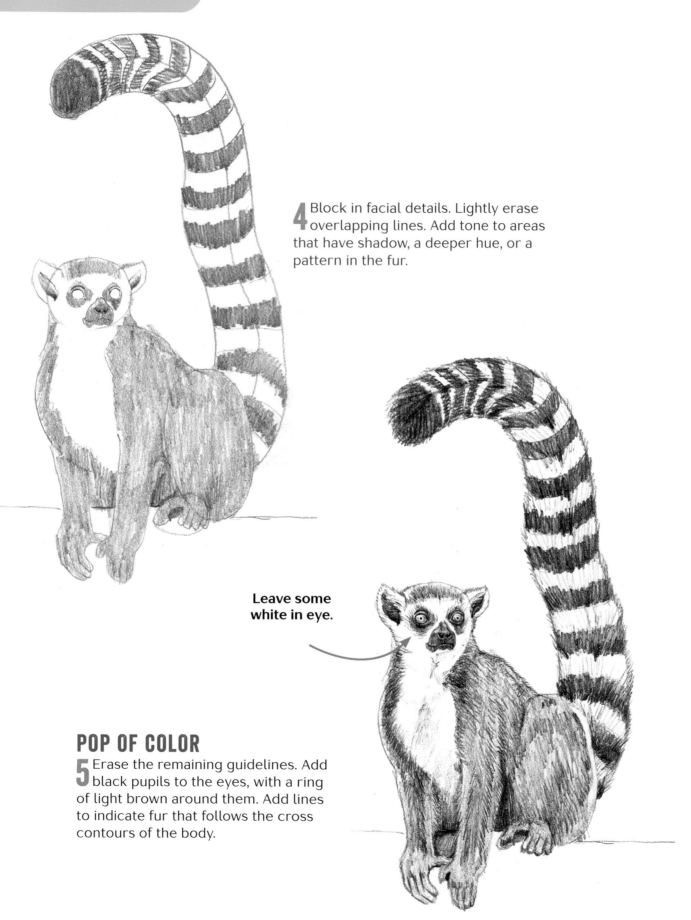

4 Block in facial details. Lightly erase overlapping lines. Add tone to areas that have shadow, a deeper hue, or a pattern in the fur.

Leave some white in eye.

POP OF COLOR
5 Erase the remaining guidelines. Add black pupils to the eyes, with a ring of light brown around them. Add lines to indicate fur that follows the cross contours of the body.

Leave one white dot as a highlight.

6 Add more dark brown to the eyes, with yellow as a highlight. Darken shadows, but use a kneaded eraser to draw fur lines in those areas.

Use more fur lines in lighter areas.

Blend tail more to soften.

QUICK TIP
Shape your kneaded eraser into a point to create thin lines with it.

FINISHING TOUCHES
7 Carefully blend the tones with a blending tool. Add more darkness to any areas that were smoothed out to a neutral gray. Use a kneaded eraser to highlight light areas.

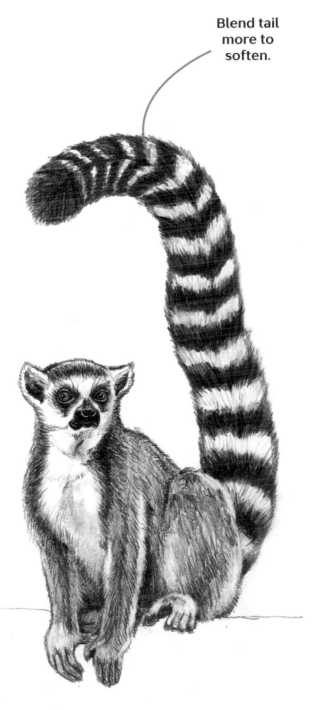

Chapter 2
BEAUTIFUL BIRDS

Soar with the eagles—and dive with the penguins—in this chapter on how to draw birds from around the world. You'll learn how to draw feathery friends both familiar and foreign, in a variety of different media. Put these lessons to use next time you see a hummingbird at your bird feeder or look at the flamingos at the zoo!

FLAMINGO

Use contrast between shadows and highlights to make this flamingo come to life, even without any pink coloring.

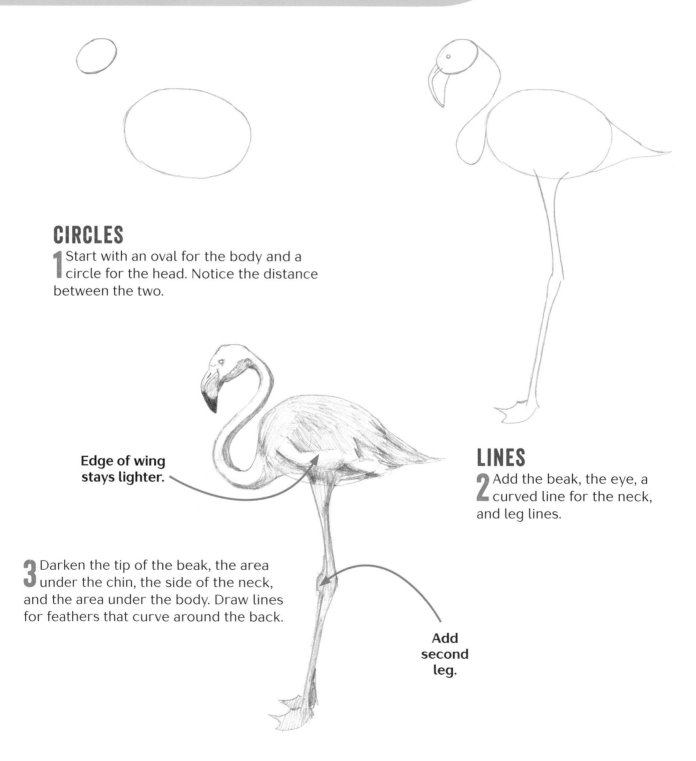

CIRCLES

1 Start with an oval for the body and a circle for the head. Notice the distance between the two.

LINES

2 Add the beak, the eye, a curved line for the neck, and leg lines.

Edge of wing stays lighter.

3 Darken the tip of the beak, the area under the chin, the side of the neck, and the area under the body. Draw lines for feathers that curve around the back.

Add second leg.

4 Add detail to the head. Deepen the tone on the beak, neck, and one side of the leg. Add lines that follow the direction of the feathers.

Tiny pupil in eye

QUICK TIP
Follow the cross contours of the body to start indicating shadows and tone.

DARKEN SHADOWS
5 Darken the neck shadow and blend the tones using a blending tool. Darken under the wing and other shadow areas.

Add pattern and more contrast to legs.

HIGHLIGHT
6 Deepen shadows even further if desired. Use a kneaded eraser to highlight the lightest spots, creating more contrast and interest.

KING PENGUIN

Found on islands across the Antarctic Ocean, the king penguin is slightly smaller than its more famous cousin, the emperor penguin—but it's no less fun to draw!

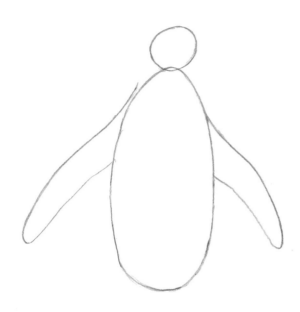

1 Start with an oval body and a small circular head that slightly overlaps the body. Use curved lines for the wings.

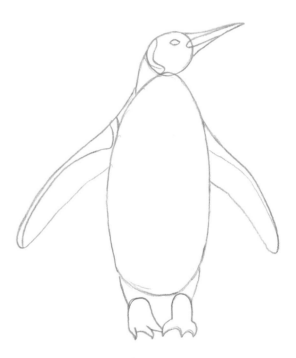

2 Add details to the face, wings, and feet.

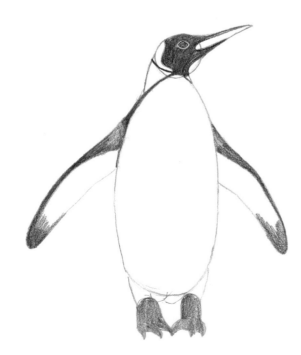

BLOCK PATTERN IN

3 Refine the neck. Add a layer of tone to block in areas of darkness.

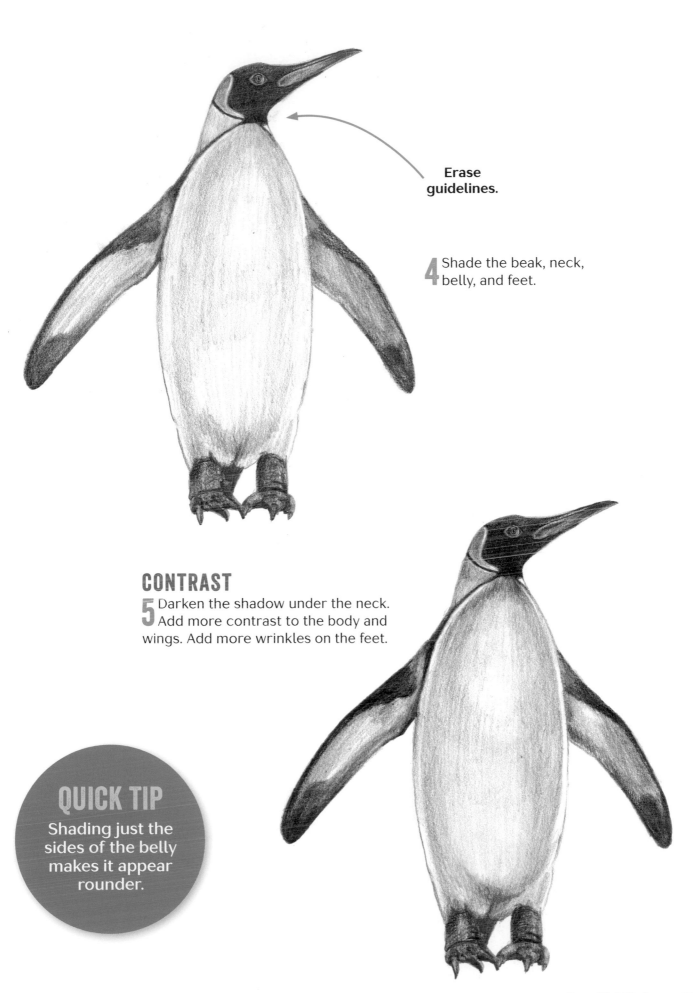

Erase guidelines.

4 Shade the beak, neck, belly, and feet.

CONTRAST

5 Darken the shadow under the neck. Add more contrast to the body and wings. Add more wrinkles on the feet.

QUICK TIP

Shading just the sides of the belly makes it appear rounder.

EAGLE

Hatch marks can be a great technique for drawing both fur and feathers. Here we'll use them for the plumage on a bald eagle.

1 Start with an oval head, a small circle for the eye, and a smaller circle for the pupil. Draw neck lines.

2 Add a hood over the eye and a beak. Draw the torso, separating the neck from the chest with short lines to represent feathers.

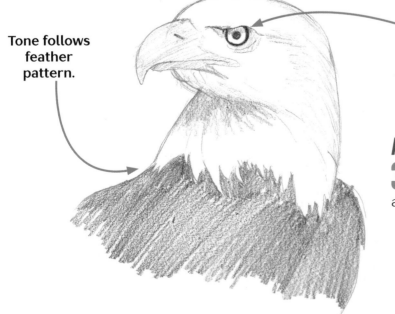

Tone follows feather pattern.

Color in pupil and rim eye with dark tone.

ADD TONE

3 Erase guidelines that are no longer needed. Add light tone to the beak and areas of shadow.

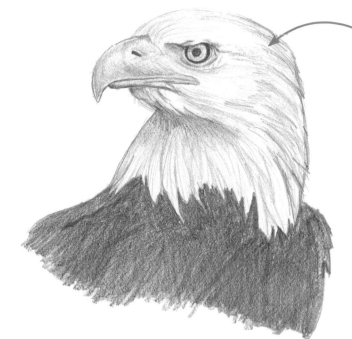

Lines follow
direction of
feather growth.

START FEATHERS

4 Darken the chest and areas of shadow.
Add lines for feathers on the white
part of the head.

QUICK TIP

Use a kneaded
eraser to add a
highlight to the eye
and draw outlines
of feathers on the
chest.

5 Darken the chest more,
and use a kneaded eraser
to draw in a few curves for
feathers. Smooth with a
blending tool.

Curves for
feathers

Deepen
shadows
around
eye.

HATCH MARKS

6 Darken the beak a bit to create
contrast with the face. Draw short
hatch marks on the white feathers for
detail.

KINGFISHER

In this lesson, we'll draw with oil pastels—or "paint" with oil pastels, as some artists like to say. Oil pastels are thicker than pencils, so expect small detail work to be a little more challenging than usual.

START WITH PENCIL

1 Draw a small circle for the head and an oval for the body. Add a smaller circle for the eye, a triangular tail shape, and a curved wing shape.

These shapes will be in different colors.

2 Add beak lines and connect the head to the body with curves. Add the tip of the back wing. Add a branch and feet with claws.

ADD OIL PASTELS

3 Erase guidelines and any other dark lines that will interfere with the coloring process. Add a light layer of hue using oil pastels to map out which colors go where.

4 Darken the pigment, pressing harder so that most of the paper tone underneath is covered. Add white in areas of highlight to smooth the tone. For shadows or darker areas, use a deeper shade of the same color: dark blue on lighter blue, brown on yellow/orange, etc.

Dark blue lines on lighter blue background

BLEND AND REFINE

5 Smooth with a blending tool or lighter shades of the same color to remove even more paper tone. Refine the feathers by drawing lines of a darker tone. Add shadows with darker tones.

QUICK TIP

For a fine line like the one on this bird's beak, scratch some pigment off with your fingernail or another tool.

Dark blue scallop with white dot inside

6 Add pattern to the feathers. Use dark blue and white to highlight individual feather spots on the head and wing. Rim the head and chest with white to soften them. Use white or light blue to blend the tones on the back.

Brown for shadows on belly

HOATZIN

It's often wise to use reference photos when drawing subjects you may never see in real life, such as the hoatzin, a prehistoric-looking bird that lives in the rainforests of South America.

1 Start with a small circle for the head, a big circle for the body, a raindrop-shaped tail, and a guideline for the neck.

2 Draw simple lines for the beak, neck, and feet. Add a circle for the wing and a fan shape at the end of the tail.

Feathers follow cross contours of body.

ADD DETAIL

3 Erase overlapping lines and guidelines that are no longer needed. Add feathers and face details. Add the spikes on the head.

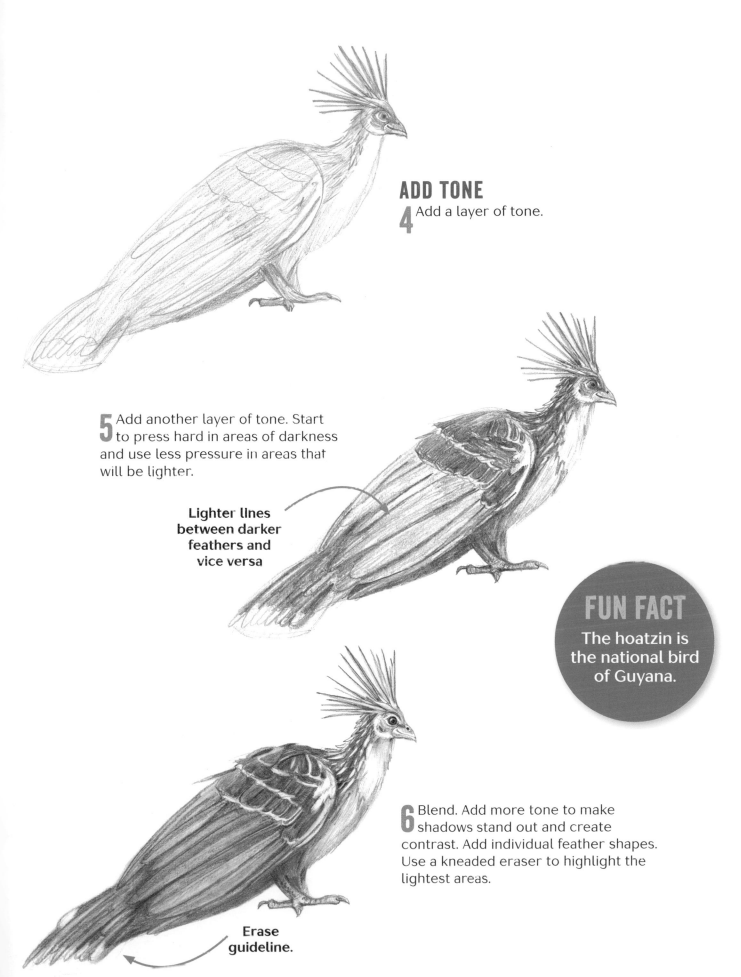

ADD TONE

4 Add a layer of tone.

5 Add another layer of tone. Start to press hard in areas of darkness and use less pressure in areas that will be lighter.

Lighter lines between darker feathers and vice versa

FUN FACT
The hoatzin is the national bird of Guyana.

6 Blend. Add more tone to make shadows stand out and create contrast. Add individual feather shapes. Use a kneaded eraser to highlight the lightest areas.

Erase guideline.

PELICAN

Using a kneaded eraser to create the feathers of this pelican's wings really makes it fly off the page.

START SIMPLE

1 Start with a small circle for the head and a larger oval for the body. Connect these shapes with two curvy neck lines, then add a long point for the beak.

2 Add details to the face, tail, and wings. Add a throat pouch to the beak. Add feet under the body.

ADD VALUE

3 Add a light layer of tone over the whole bird, pressing a bit harder in areas of deeper hue or shadow.

Press harder here.

4 Add another layer of tone. Start to form feathers as you shade.

QUICK TIP
Shape the kneaded eraser into a small point for finer lines.

5 Smooth the tones using a blending tool.

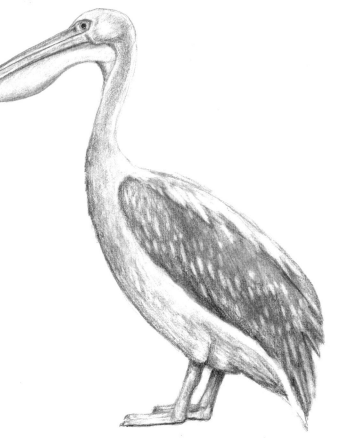

ADD FEATHERS

6 Create feathers by using a kneaded eraser to remove pigment.

Shadow under beak

7 Add short lines for feathers around the head. Add marks on the neck and chest for feathers. Darken the areas around the erased feathers on the wing.

Wrinkles and spots on feet

KIWI

PEN

Hatching and cross-hatching with a fine-tip pen (I used a Sharpie) capture the texture of the feathers on New Zealand's national bird: the kiwi. Draw carefully—you can't erase pen!

START WITH PENCIL

1 Start with a small circle for the head and a large circle for the body. Add two tiny concentric circles for the eye.

2 Connect the head and body with lines. Draw a pointy, triangular beak. Refine the body shape to show where the legs start. Add lines to indicate the legs.

Leave white spots in eye for highlight.

Lines are longer toward the back.

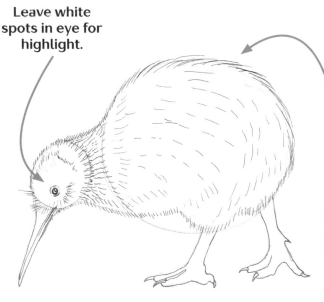

SWITCH TO PEN

3 Using a fine-tip pen, draw short hatch marks around the perimeter of the kiwi. Make sure to draw the lines in the direction the feathers grow. Outline the beak and feet.

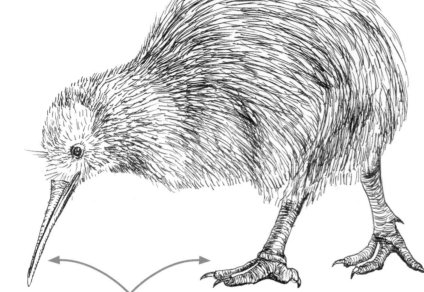

Add detail using lines and hatching.

4 Erase the pencil guidelines. Add more feather lines, drawing more in areas of shadow or dark tone, less in areas of highlight or light tone.

QUICK TIP
Keep the pencil guidelines for now. They'll help you determine the direction of the feather growth.

Longer lines look smoother.

MORE HATCHING

5 Add another layer of hatching. Use short strokes near the head and longer strokes toward the back of the body. Add another layer of hatching to the legs.

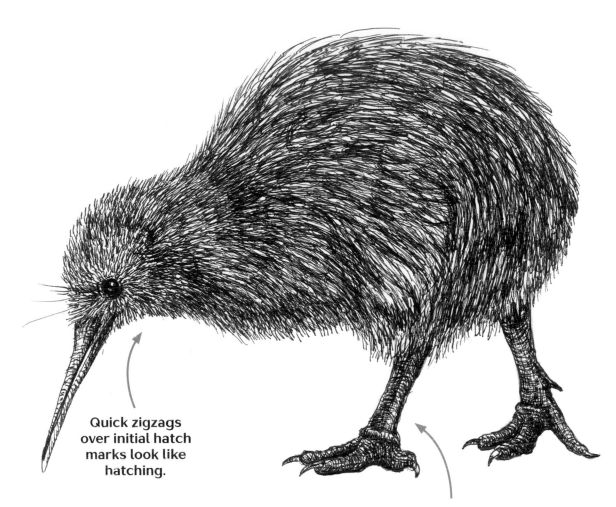

Quick zigzags over initial hatch marks look like hatching.

More hatching and cross-hatching on legs

EVEN MORE HATCHING

6 Add yet another layer of hatching. This layer should start to show contrast. Keep adding lines until you're happy with the result.

Using Layers

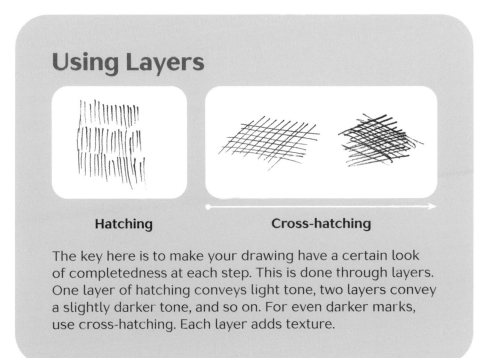

Hatching

Cross-hatching

The key here is to make your drawing have a certain look of completedness at each step. This is done through layers. One layer of hatching conveys light tone, two layers convey a slightly darker tone, and so on. For even darker marks, use cross-hatching. Each layer adds texture.

HUMMINGBIRD

Hummingbirds flap their wings up to 80 times per second! In this lesson, we'll use light, blurry lines to indicate the motion of the wings.

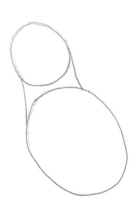

BASIC BODY SHAPE

1 Start with a small circle for the head and a slightly larger circle for the body. Connect the two with lines.

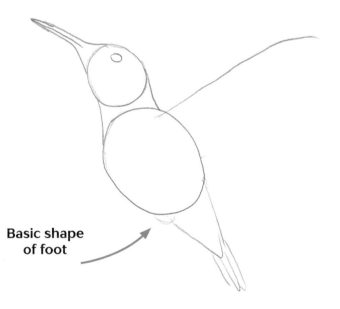

Basic shape of foot

2 Add an eye, beak, and triangular tail. Add a few feathers at the end of the tail. Draw a line as a guide for the wing.

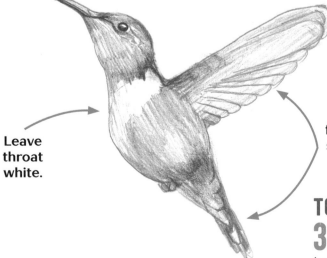

Leave throat white.

Basic feather shapes

TONE AND TEXTURE

3 Erase the guidelines. Finish the wing and add a layer of tone, pressing harder in darker areas.

PATTERN AND MOTION

4 Add the hummingbird's pattern using a combination of zigzag marks, lines, and curves. Add a few light lines above the wing so the top line is blurrier, indicating motion.

5 Add a very light layer of tone outside of the bottom of the wing to blur the edge. Add a few more light lines around the contour of the wing to indicate motion. Blend to smooth the tones.

Darken bottom feathers on wings.

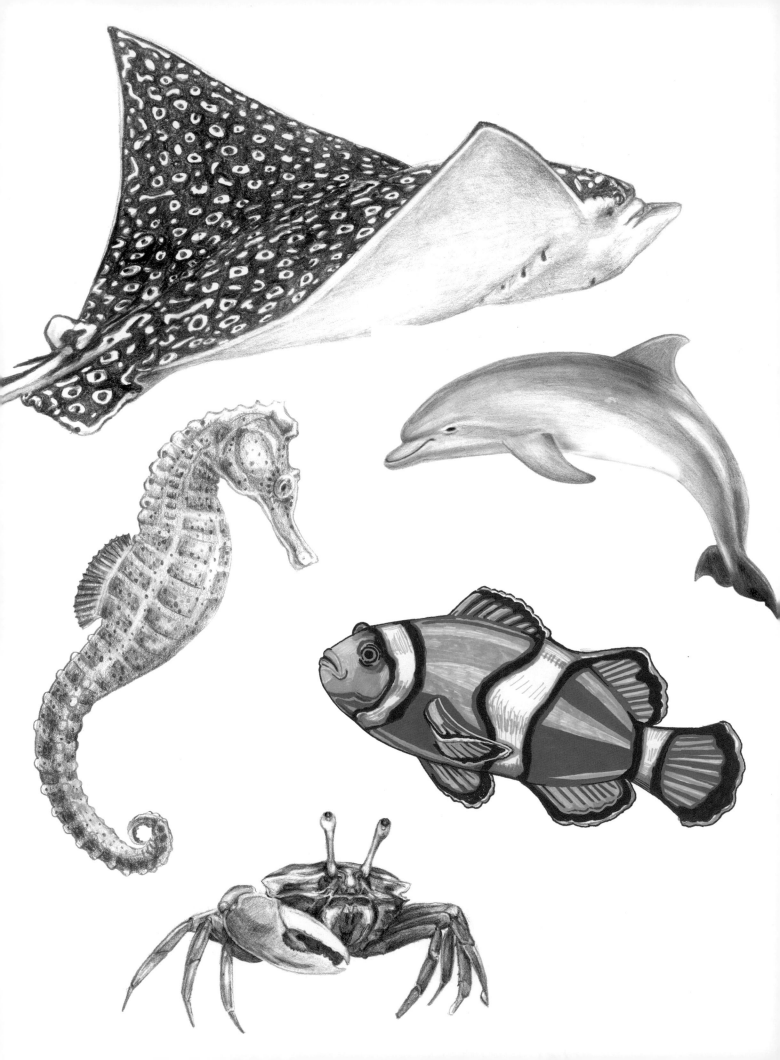

Chapter 3
UNDER THE SEA

From crabs to squid to dolphins, the animals that live in the ocean are incredibly diverse. In this chapter, we'll learn how to draw a variety of fins, tails, tentacles, and scales. We'll even use oil pastels to draw a jellyfish that seems to glow in the dark!

SPOTTED EAGLE RAY

True to its name, the spotted eagle ray is covered in distinctive black-and-white spots. Drawing this striking pattern is tricky but rewarding.

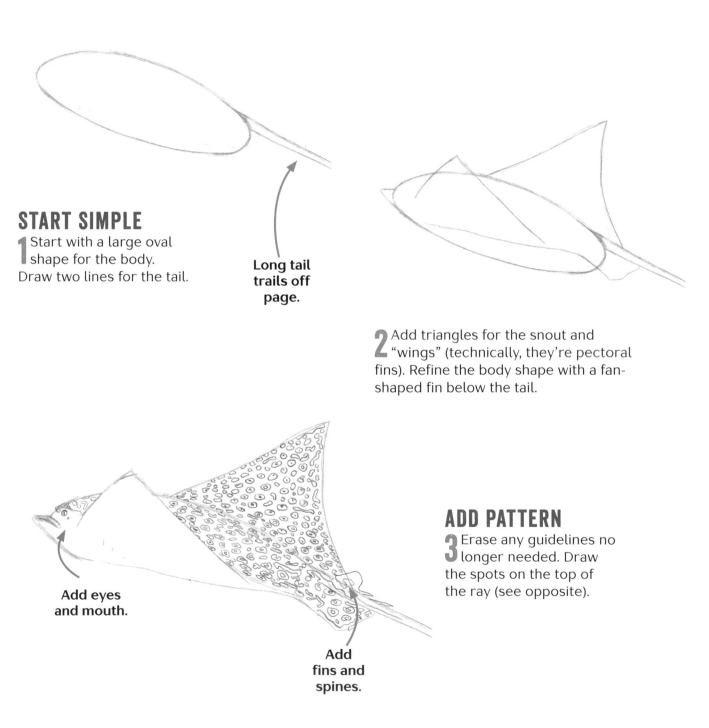

START SIMPLE

1 Start with a large oval shape for the body. Draw two lines for the tail.

Long tail trails off page.

2 Add triangles for the snout and "wings" (technically, they're pectoral fins). Refine the body shape with a fan-shaped fin below the tail.

ADD PATTERN

3 Erase any guidelines no longer needed. Draw the spots on the top of the ray (see opposite).

Add eyes and mouth.

Add fins and spines.

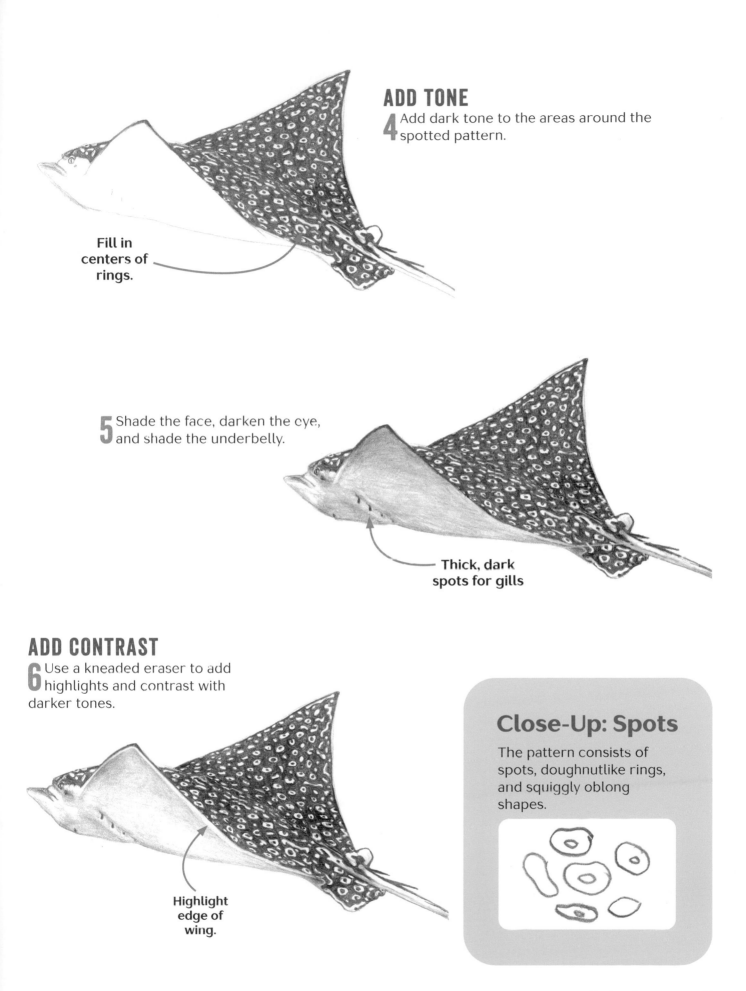

ADD TONE

4 Add dark tone to the areas around the spotted pattern.

Fill in centers of rings.

5 Shade the face, darken the eye, and shade the underbelly.

Thick, dark spots for gills

ADD CONTRAST

6 Use a kneaded eraser to add highlights and contrast with darker tones.

Highlight edge of wing.

Close-Up: Spots

The pattern consists of spots, doughnutlike rings, and squiggly oblong shapes.

FIDDLER CRAB

Male fiddler crabs have an unusual trait: one of their claws is huge, while the other is tiny. This strange-looking asymmetry is fun to draw!

START WITH OVALS

1 Start with an oval for the body and an oval for the big claw.

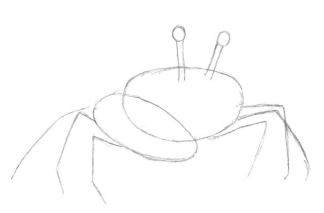

ADD LINES

2 Add eyes on stalks and guidelines for where the legs will go.

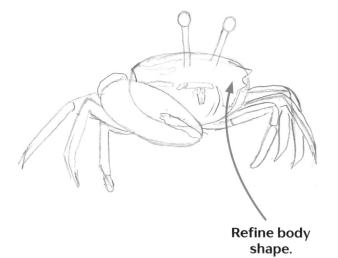

Refine body shape.

3 Add detail to the claw. Thicken the legs. Add a mouth and other details to the front of the body.

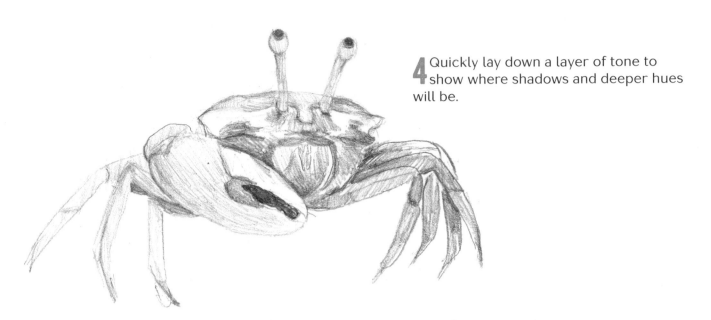

4 Quickly lay down a layer of tone to show where shadows and deeper hues will be.

BLEND

5 Blend with a blending tool, then add more tone to areas of shadow.

FUN FACT

If fiddler crabs lose a leg or claw, it grows back the next time they molt.

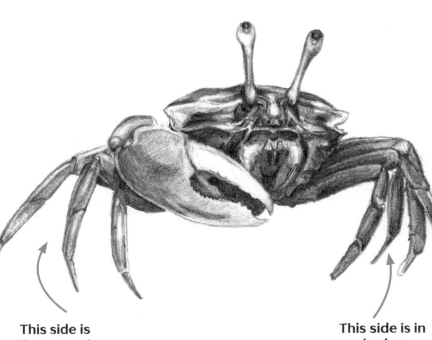

FINISHING TOUCHES

6 Add details, contrast, and shadows.

This side is illuminated.

This side is in shadow.

JELLYFISH

It's time to think outside the pencil case with a project that uses oil pastels! The dark background behind the lighter-colored jellyfish gives the illusion of a faint bioluminescent glow.

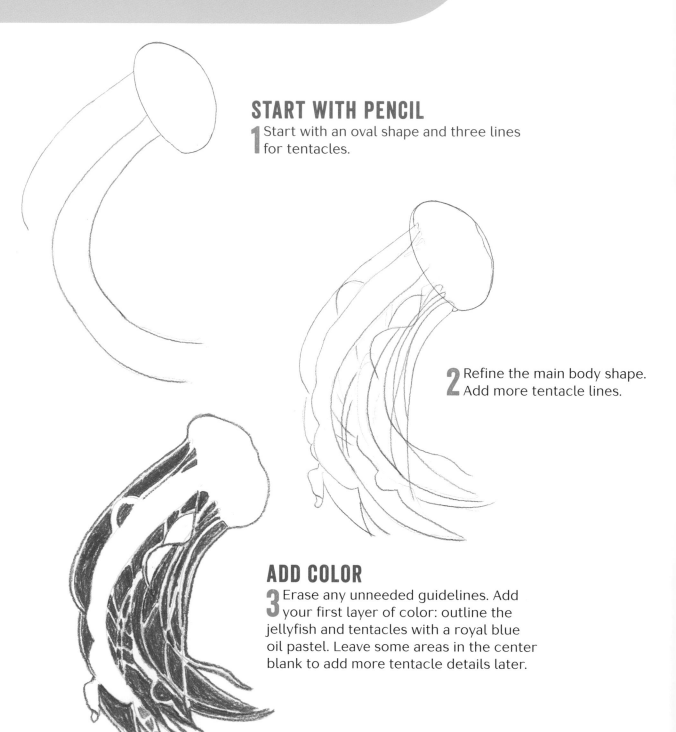

START WITH PENCIL

1 Start with an oval shape and three lines for tentacles.

2 Refine the main body shape. Add more tentacle lines.

ADD COLOR

3 Erase any unneeded guidelines. Add your first layer of color: outline the jellyfish and tentacles with a royal blue oil pastel. Leave some areas in the center blank to add more tentacle details later.

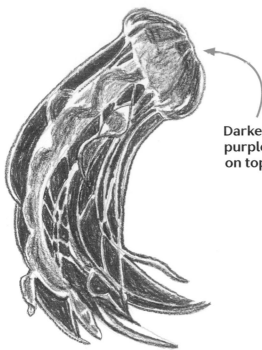

Darker purple on top

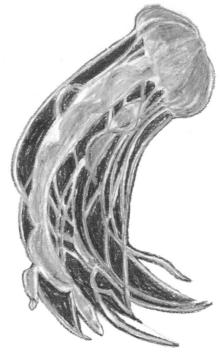

4 Using the side of the oil pastel, block in the jellyfish's body with purple and pink, and draw the curves of the centermost tentacle. Fill in a few areas with light blue.

5 Use a white oil pastel to blend the body and tentacles. This should smooth out the tone and lighten the color significantly.

QUICK TIP

If the layers become too thick, you can scratch some off with your fingernail.

Lighten any area with white to give a glowy appearance.

6 Add more layers of pink and purple on the body, then red to highlight the purple. Use dark blue for the background. Press hard and try to leave zero paper tone. Add scalloped edges and more purple to the thicker tentacles. Use white to blend tones together and smooth edges.

7 Use white as a blender over all the tentacles and in the ridges of the body. Fill in the remainder of the background with dark blue. Add more contrast with dark and light hues of your choice.

GREAT WHITE SHARK

The iconic great white shark is actually mostly gray. A few layers of tone and blending bring this ferocious fish to life.

1 Start with a long, oval-like shape, thinner at one side, for the body. Add a rounded triangle pointing up for the top of the head, and a smaller rounded triangle below for the jaw.

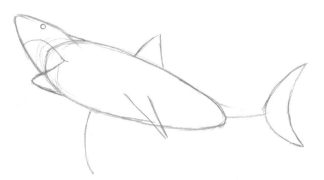

GUIDELINES
2 Sketch in shapes for the eye, mouth, fins, and tail.

Add pupil and nostrils.

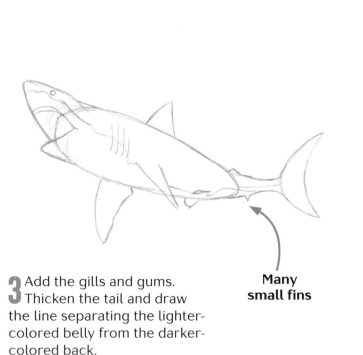

Many small fins

3 Add the gills and gums. Thicken the tail and draw the line separating the lighter-colored belly from the darker-colored back.

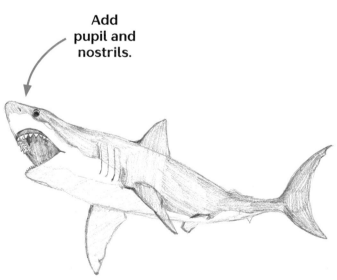

FIRST LAYER OF TONE
4 Erase the original guidelines. Draw teeth. Add a light layer of tone, darker in the mouth, lighter on the belly.

5 Add another layer of tone. Add some light tone under the belly for shadow.

Note where shadow is darkest.

6 Smooth the tones with a blending tool. Add more contrast as needed.

FINISHING TOUCHES

7 Blend more. Use a kneaded eraser to lighten the highlights.

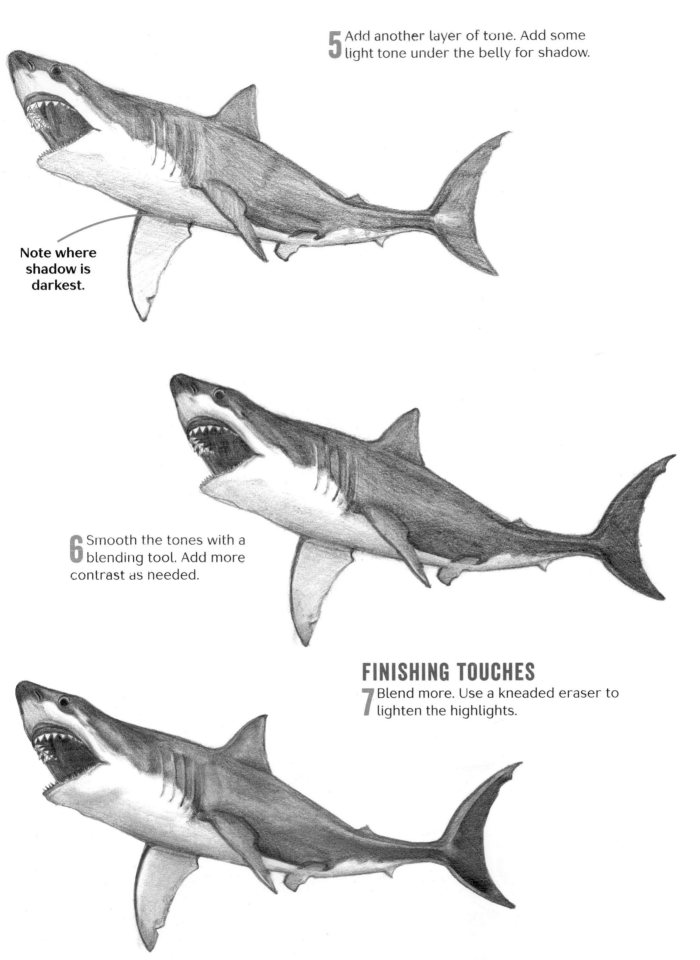

GOLDFISH

OK, so technically speaking, goldfish aren't sea creatures; they're freshwater fish. But they're a great way to practice drawing scales and fins, especially if you have one at home for reference!

BASIC SHAPES

1 Start with an oval for the body. Add a circle for the eye and guidelines for the tail.

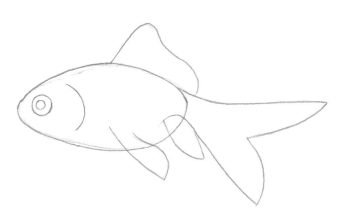

2 Add a pupil in the eye and a curved line for the gill. Complete the tail and add three more fins.

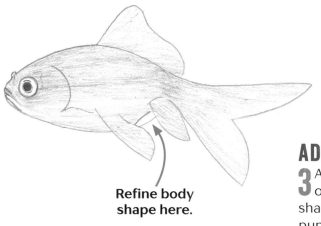

Refine body shape here.

ADD TONE

3 Add lips and a bump for the eye on the other side of the fish. Refine the body shape and erase the guidelines. Fill in the pupil and add a layer of tone over the whole fish.

4 Add a few curved lines for scales. Add shading to create depth. Add lines to the fins.

Note shadows and highlights on face.

SHADOWS AND HIGHLIGHTS

5 Darken shadows more. Make the lines in the fins deeper. Shade in a subtle scale pattern. Use a kneaded eraser to lighten the tops of the fins. Add more, lighter fin lines.

Darken shadows and lighten highlights.

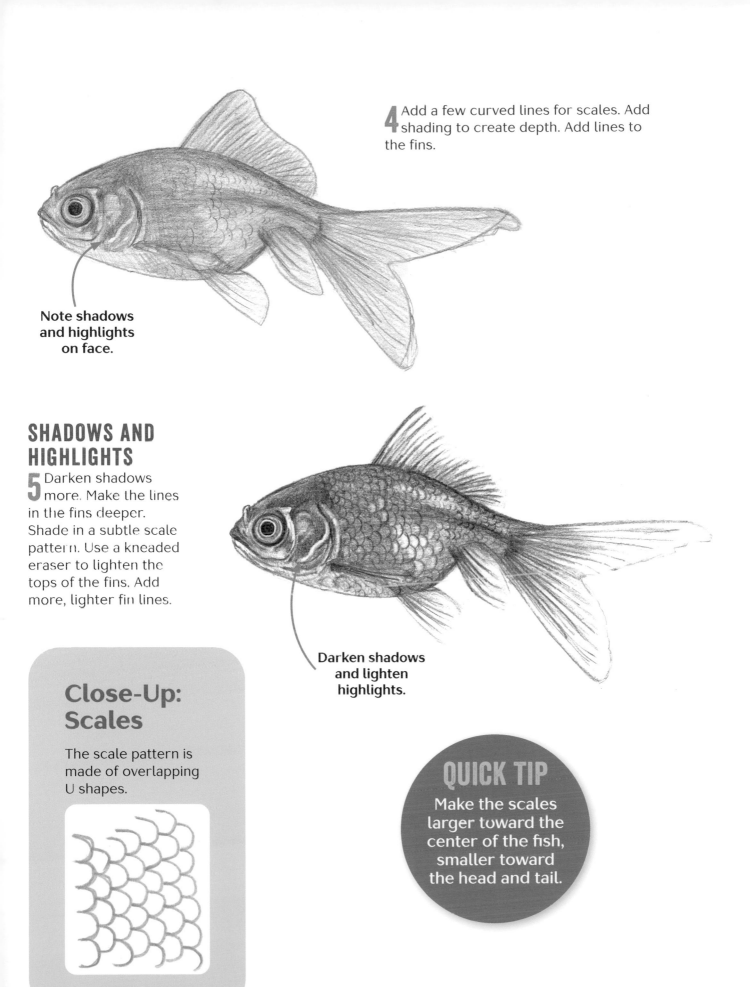

Close-Up: Scales

The scale pattern is made of overlapping U shapes.

QUICK TIP

Make the scales larger toward the center of the fish, smaller toward the head and tail.

CLOWNFISH

It's fun to experiment with different media. Have you ever drawn with Sharpies or similar permanent markers? It's a great way to capture the bright colors of a clownfish!

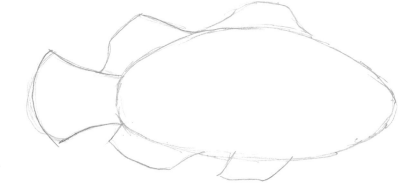

START WITH PENCIL

1 Start with an oval for the body. Add lines and curves for the fins.

2 Add details to the fins and face. Don't forget the iconic stripes!

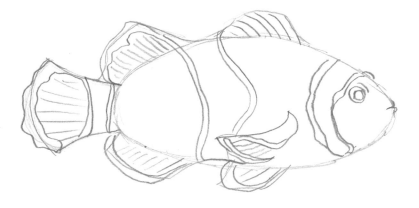

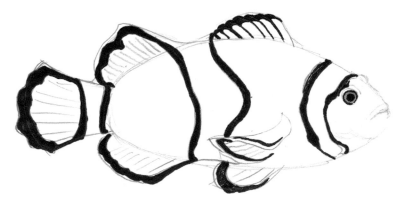

SWITCH TO MARKER

3 Use a black Sharpie or other permanent marker to fill in the black stripes and pupil. Rim the eye with a fine-tipped marker in a light orange color.

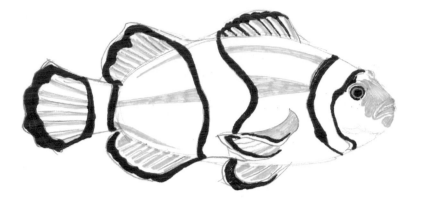

4 Use a light yellow-orange to fill in what will become the highlights on the face, the fins, and the center and edges of the body.

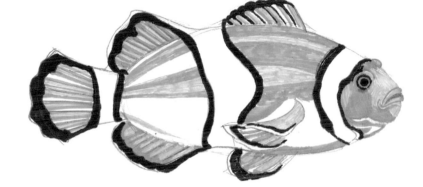

QUICK TIP

Use a lighter, greener shade of blue for lighter shadows, and a darker, purpler shade of blue for darker shadows. The places where they overlap will create a third shade of blue.

5 Use a slightly darker shade of orange to fill in the midtones.

Light source is here.

Underside in shadow

FINISH COLORS

6 Use a darker shade of orange to fill in the core shadow. Use blue markers to rim the fins and add shadow to the stripes. Outline the final drawing with a thin black marker.

SQUID

Squid have eight arms and two tentacles, which makes for a great lesson in drawing objects that overlap. Pay attention to which lines go in front of others and which go behind.

1 Start with a circle shape for the head and a smaller circle for the eye. Add a long triangular "hat" for the mantle.

2 Add a few curved guidelines for arms and tentacles. (We'll make more soon!)

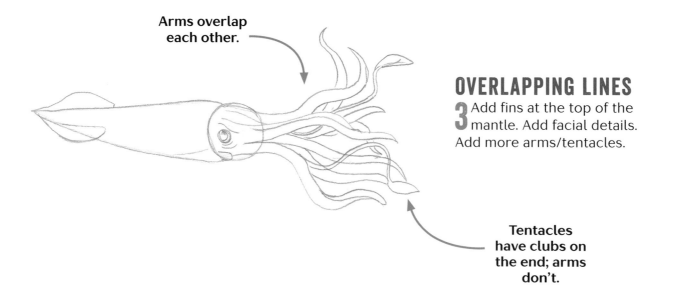

Arms overlap each other.

OVERLAPPING LINES

3 Add fins at the top of the mantle. Add facial details. Add more arms/tentacles.

Tentacles have clubs on the end; arms don't.

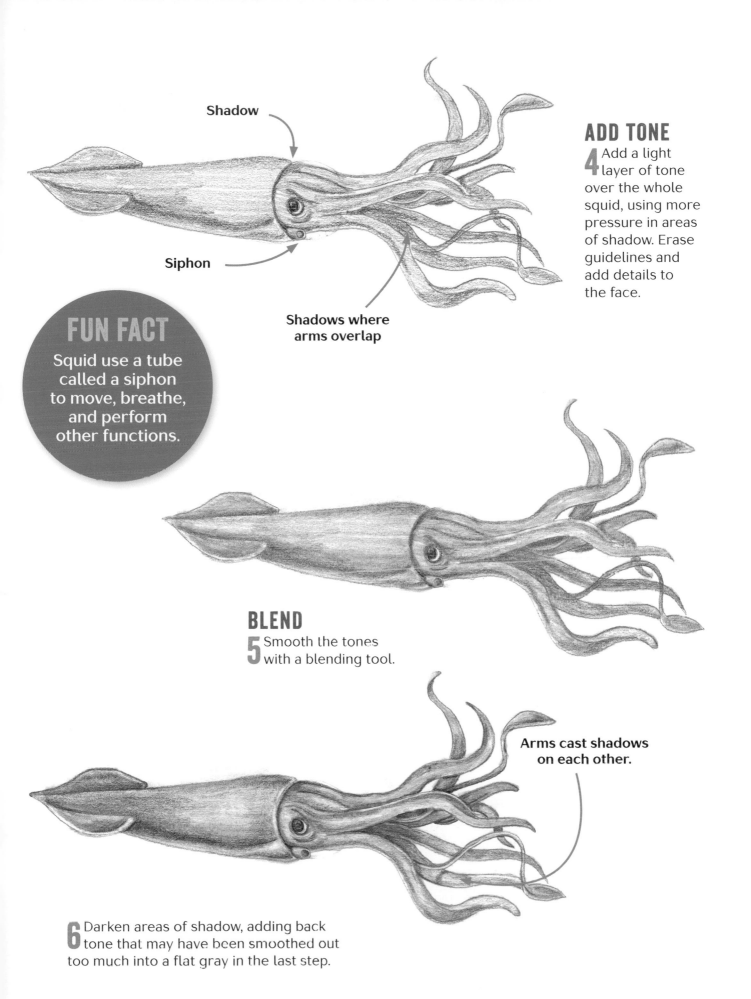

Shadow

Siphon

ADD TONE
4 Add a light layer of tone over the whole squid, using more pressure in areas of shadow. Erase guidelines and add details to the face.

Shadows where arms overlap

FUN FACT
Squid use a tube called a siphon to move, breathe, and perform other functions.

BLEND
5 Smooth the tones with a blending tool.

Arms cast shadows on each other.

6 Darken areas of shadow, adding back tone that may have been smoothed out too much into a flat gray in the last step.

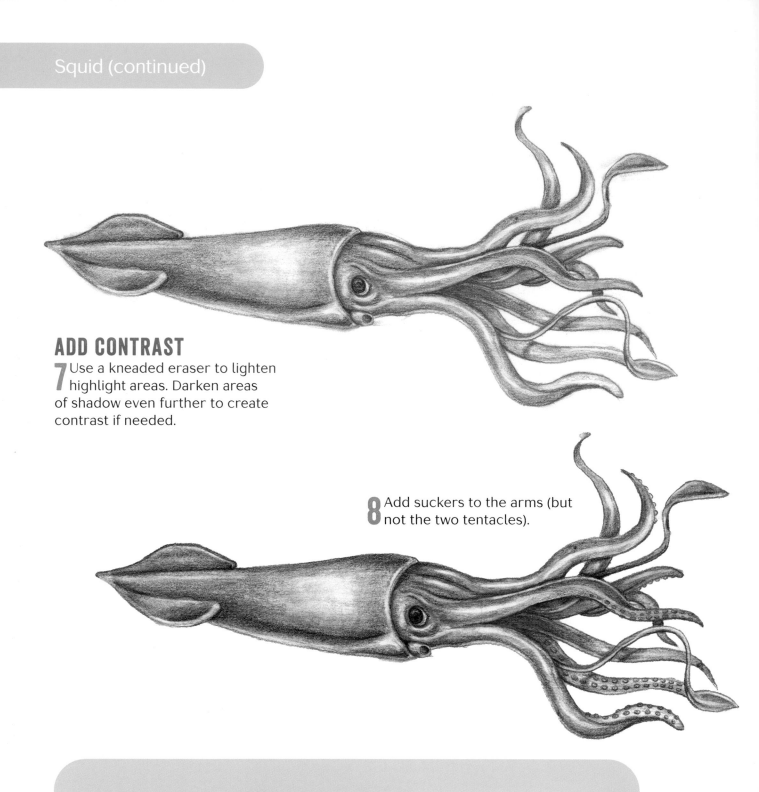

ADD CONTRAST

7 Use a kneaded eraser to lighten highlight areas. Darken areas of shadow even further to create contrast if needed.

8 Add suckers to the arms (but not the two tentacles).

Close-Up: Sucker

The suckers resemble squashed bull's-eye symbols. The more they angle away from the viewer, the more squashed they look. This is because the pattern is more or less circular, but when drawn in perspective, a circle can become an ellipse.

SEA TURTLE

Though they spend their lives in the ocean, sea turtles lay their eggs on land. In this tutorial, we'll draw a baby sea turtle hatching from one of those eggs, using a technique called stippling for the sand on the beach.

1 Start with a small circle for the head, with a larger circle for the eggshell overlapping it.

SIMPLE SHAPES

2 Erase the guideline going through the head. Add basic shapes for the eyes, snout, flipper, and crack in the eggshell.

Add shadow around edges of crack in eggshell.

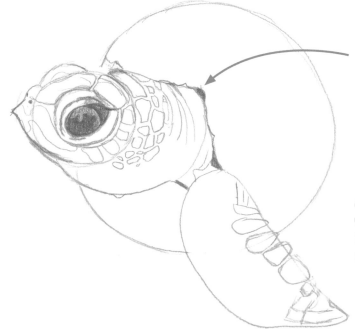

3 Erase any guidelines no longer needed. Block in the eye with tone. Start to add pattern to the skin on the head and flipper.

ADD PATTERN

4 Start blocking in the pattern on the head with tone. Add a light layer of tone to the flipper. Draw more pattern on the flipper.

QUICK TIP

To soften the lines, draw over the pattern with a dark pencil (e.g., 9B), using a light touch. A dull pencil works great for this, as you don't get a sharp line.

5 Darken the eye and add pattern around it. Add a layer of tone to the turtle's neck and head. Gently blend the head and flipper to smooth the tone (but don't overblend, or you'll smear the pattern into a flat gray).

Tone follows cross contours.

6 Use a kneaded eraser to create highlights and lighten the upper edges of the egg. Darken areas of shadow using a 6B pencil. Add some light tone to the underside of the egg for shadow. Blend with a blending tool. Add stippling to indicate sand.

Denser stippling directly under egg conveys shadow.

Stippling

Stippling is a method of shading that uses lots of small dots. The closer together the dots are in a given area, the darker that area appears; the farther apart they are, the lighter the area appears. It can be time-consuming to draw all those dots, but it creates a wonderful effect—especially in this case, when we're trying to draw a shadow on sand.

SEAHORSE

Notice how the pattern on this seahorse follows the cross contours of the body, making it look three-dimensional.

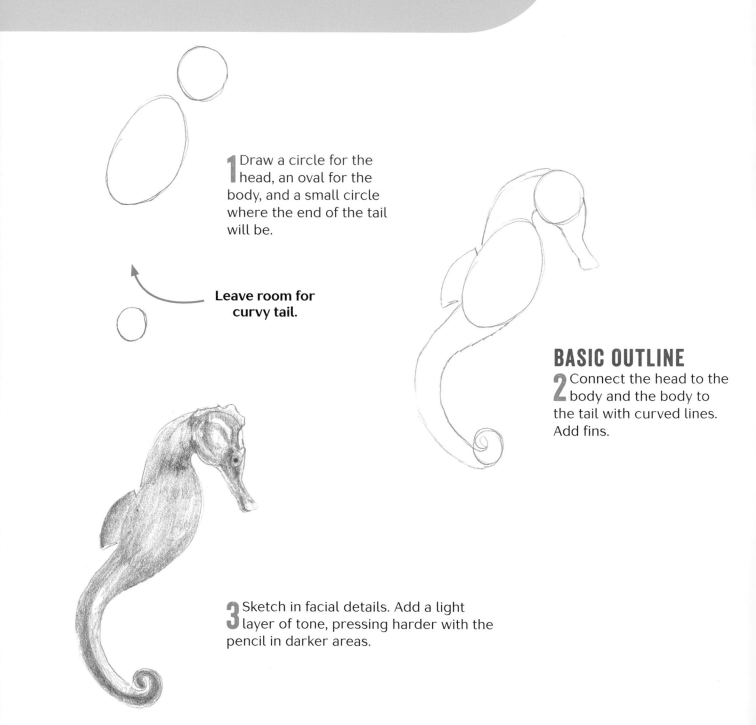

1 Draw a circle for the head, an oval for the body, and a small circle where the end of the tail will be.

Leave room for curvy tail.

BASIC OUTLINE
2 Connect the head to the body and the body to the tail with curved lines. Add fins.

3 Sketch in facial details. Add a light layer of tone, pressing harder with the pencil in darker areas.

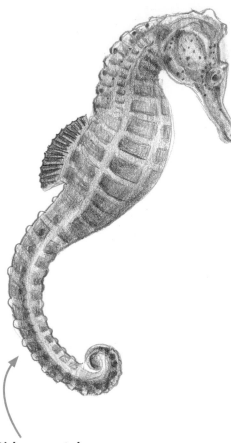

ADD PATTERN

4 Add the pattern, following the cross contours of the body. Shade darker on one side of the pattern and lighter on the other. Add lines to the back fin. Add bumpy ridges along the length of the spine.

Ridges match width of pattern.

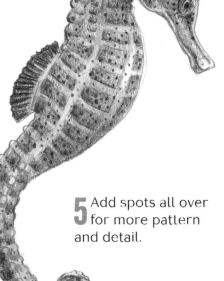

5 Add spots all over for more pattern and detail.

HIGHLIGHTS AND CONTRAST

6 Erase certain areas to create highlights. Add contrast and clean up the edges.

DOLPHIN

Starting with an arch for this drawing helps capture the elegant motion of a dolphin leaping out of the water. Don't worry about smudging in step 5; you'll fix it in step 6!

1 Start with a large arch.

2 Add an oval nose and a curved belly. Start outlining the tail.

3 Add a mouth, eye, and fins. Finish outlining the tail.

Notches in tail

Pencil strokes follow cross contours.

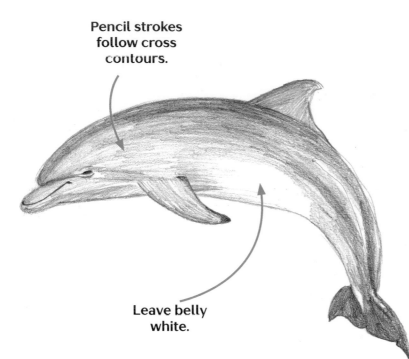

Leave belly white.

ADD VALUE

4 Erase any guidelines that are no longer needed. Add a light layer of tone, using more pressure on the tail and the arch of the back.

BLEND

5 Use a blending tool or tissue to smooth the tones.

6 Clean up smudges. Use a kneaded eraser to create highlights. Go over darker areas with more pressure to create contrast.

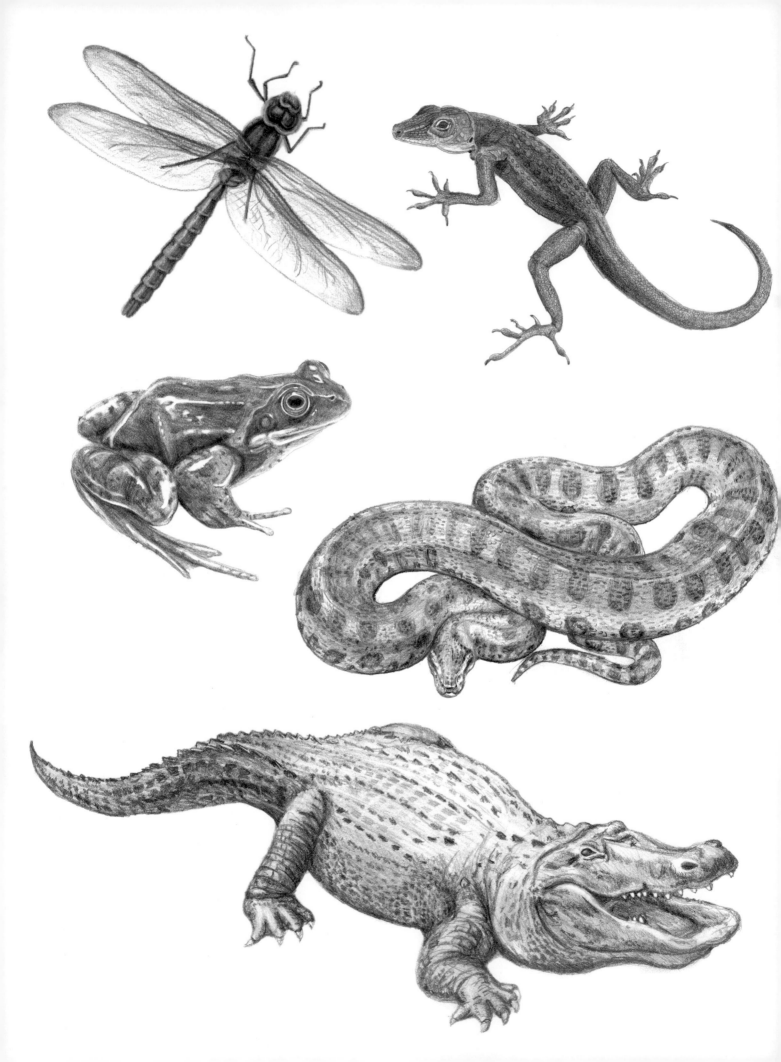

Chapter 4
CREEPY CRAWLIES

Snakes, spiders, and other creepy-crawly animals don't always get enough love. In this chapter, we'll dive into drawing reptiles, bugs, and more, learning several different techniques along the way. If you want to know how to draw the tiny hairs on a tarantula or the intricate pattern of scales on an anaconda, this chapter's for you!

DRAGONFLY

COLORED PENCIL

It may seem counterintuitive, but colored pencils can be the perfect tool for drawing transparent things, like this dragonfly's wings. They also work well for its iridescent body.

1 Start with a small circle for the head. Draw a long line coming from it as a guide for the rest of the body.

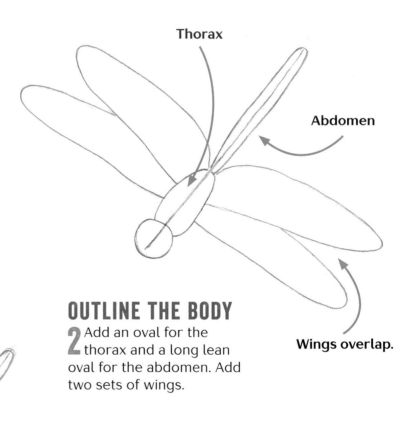

Thorax

Abdomen

Wings overlap.

OUTLINE THE BODY

2 Add an oval for the thorax and a long lean oval for the abdomen. Add two sets of wings.

3 Draw legs. Add veins to the wings.

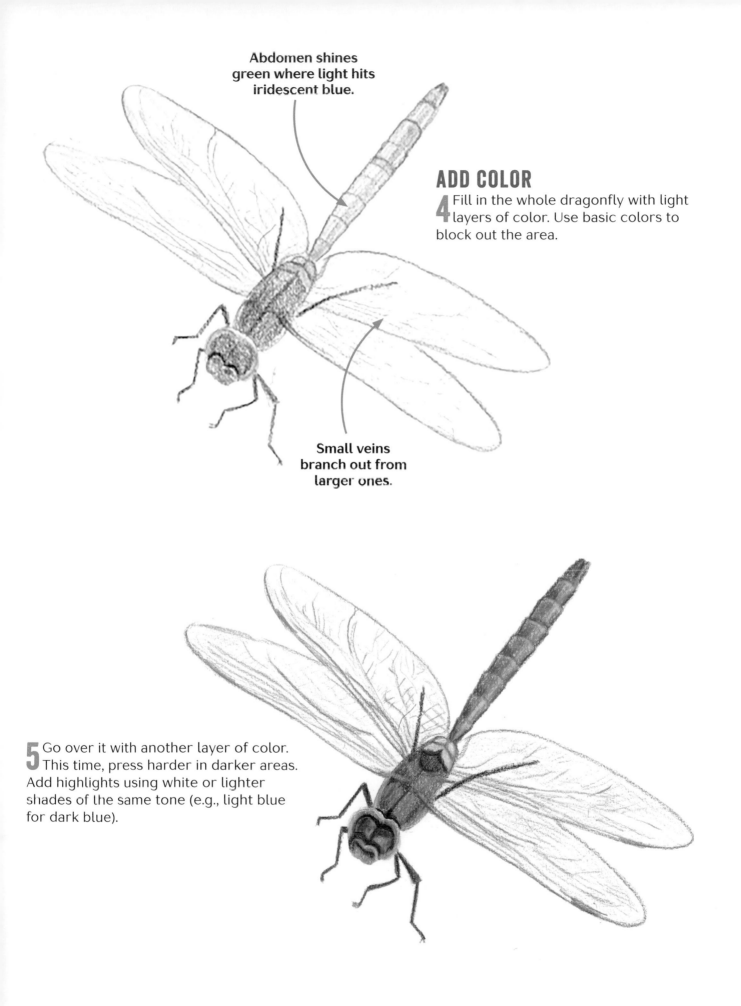

**Abdomen shines
green where light hits
iridescent blue.**

ADD COLOR

4 Fill in the whole dragonfly with light layers of color. Use basic colors to block out the area.

**Small veins
branch out from
larger ones.**

5 Go over it with another layer of color. This time, press harder in darker areas. Add highlights using white or lighter shades of the same tone (e.g., light blue for dark blue).

Chartreuse highlight

Yellow ochre highlights

ADD DEPTH TO THE COLOR

6 Fill in the front of the thorax with darker browns and greens. Rim the back of the thorax with light blue and green, then blend with white. Darken the abdomen with deep blue or purple. Trace some of the wing veins with a drawing pencil (such as a 2B) to make them stand out. Rim the head in white or a light color.

Shade where wings overlap.

Shadow on abdomen segments

QUICK TIP

To make the wings look transparent, use an eraser to create white lines where they overlap the thorax. (Yes, colored pencil does erase, though usually not completely.)

7 Use an eraser to lighten highlights even more. Rim the dragonfly with a warm yellow to make it appear to glow. Lightly add greens and yellows to the wings to add more color and dimension.

ALLIGATOR

Getting the rough, scaly texture of this alligator's skin right will make it come to life—just watch out for those jaws!

1 Start with an oval body. Add a circle-shaped head overlapping it. Draw a line for the tail. Add lines to indicate where the legs will go.

SKETCHING SHAPES

2 Add more detail to the legs, indicating placement and position. Thicken the tail and add rough lines where the mouth will go.

Short horizontal lines mark edge of snout.

3 Use the guidelines to add detail to the mouth and legs. Add claws and eyes. Draw guidelines along the back where the scutes (bony plates) will go.

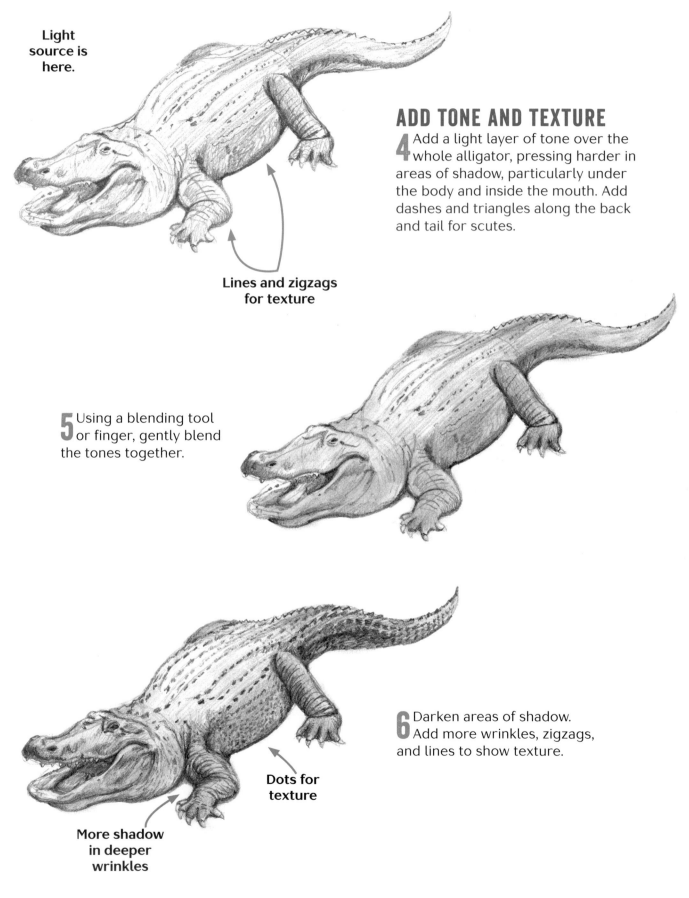

Light source is here.

ADD TONE AND TEXTURE

4 Add a light layer of tone over the whole alligator, pressing harder in areas of shadow, particularly under the body and inside the mouth. Add dashes and triangles along the back and tail for scutes.

Lines and zigzags for texture

5 Using a blending tool or finger, gently blend the tones together.

6 Darken areas of shadow. Add more wrinkles, zigzags, and lines to show texture.

Dots for texture

More shadow in deeper wrinkles

FINISHING TOUCHES

7 Add more tone and pattern. Darken areas of shadow. Smooth the tones with a blending tool or finger. Erase lighter areas to create highlights.

QUICK TIP

Don't overblend everything into a single shade of gray. Those differing tones add depth!

Alligator vs. Crocodile

How can you tell the difference between an alligator and a crocodile? In general, alligators have rounder, more U-shaped snouts, and crocodiles have pointier, more V-shaped snouts.

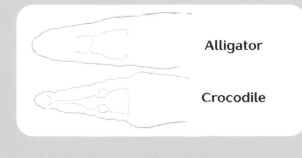

Alligator

Crocodile

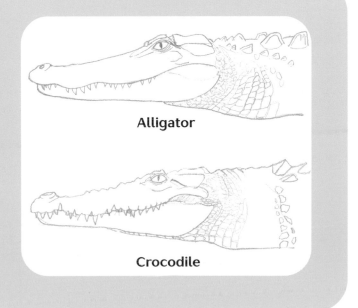

Alligator

Crocodile

ANACONDA

This anaconda's coils overlap each other. As you draw, pay attention to where the lines cross each other and which sections of the snake block other sections from view.

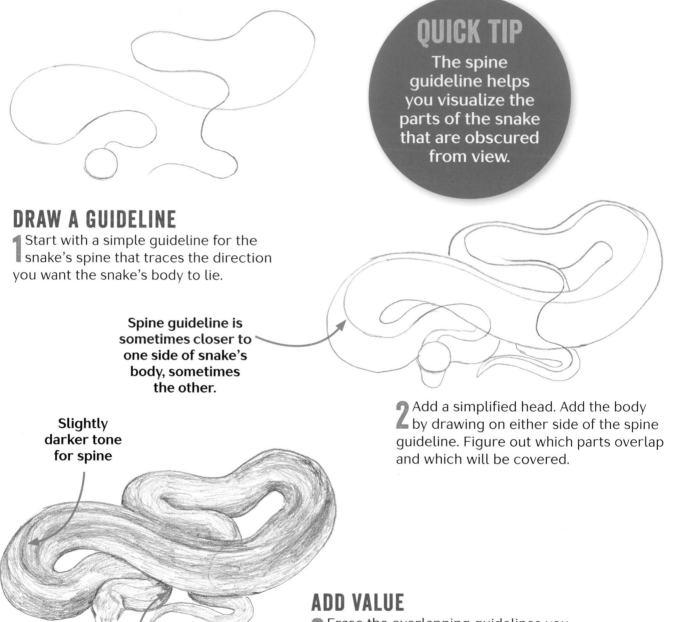

DRAW A GUIDELINE

1 Start with a simple guideline for the snake's spine that traces the direction you want the snake's body to lie.

Spine guideline is sometimes closer to one side of snake's body, sometimes the other.

QUICK TIP
The spine guideline helps you visualize the parts of the snake that are obscured from view.

2 Add a simplified head. Add the body by drawing on either side of the spine guideline. Figure out which parts overlap and which will be covered.

Slightly darker tone for spine

ADD VALUE

3 Erase the overlapping guidelines you no longer need. Add a light layer of tone to block in the major forms. Add some facial details.

Curves create shadows.

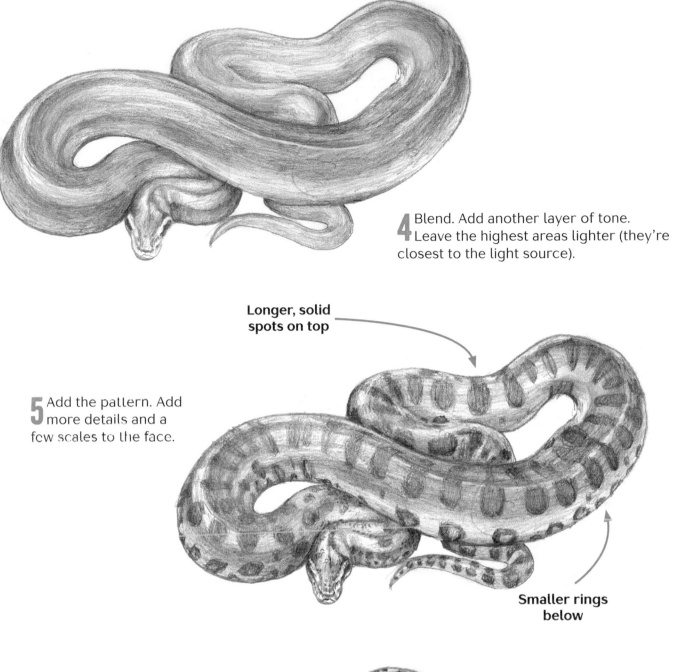

4 Blend. Add another layer of tone. Leave the highest areas lighter (they're closest to the light source).

Longer, solid spots on top

5 Add the pattern. Add more details and a few scales to the face.

Smaller rings below

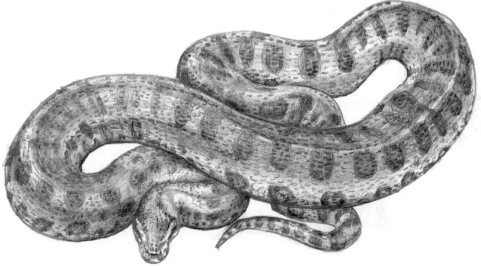

ADD TEXTURE

6 Blend. Deepen the tone in darker areas to add contrast. Add small curves and circles for scales.

SNAIL

Most garden snails don't have green shells, but that's the fun of colored pencils—you can choose whichever colors you like!

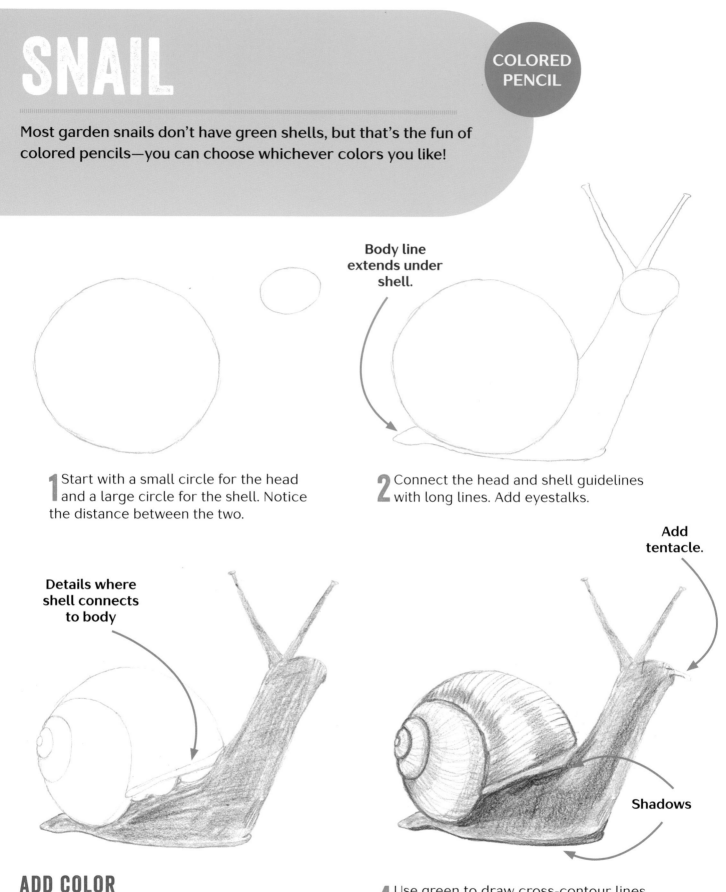

Body line extends under shell.

1 Start with a small circle for the head and a large circle for the shell. Notice the distance between the two.

2 Connect the head and shell guidelines with long lines. Add eyestalks.

Details where shell connects to body

Add tentacle.

Shadows

ADD COLOR

3 Add concentric circles for the swirl of the shell. Erase guidelines. Add a layer of light brown to the snail's body.

4 Use green to draw cross-contour lines following the spiral of the shell. Block out shadows in dark green and highlights in light green. Use dark brown for shadows on the body.

Outline
eyestalks.

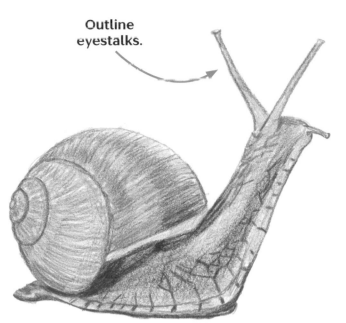

BLEND WITH COLOR

5 Add a streak of brown to the middle of each spiral on the shell. Then use light green to blend the colors. Use dark brown to add the pattern to the body.

DEEPEN COLOR

6 Use layers of light brown, dark brown, black, and cream on the head and body to make the pattern. Use white to blend the paper tones in the lightest areas. Draw layers of green, light green, and dark green lines on the shell.

QUICK TIP

Lighten pencil outlines with a kneaded eraser so they don't have a darker tint to them when colored.

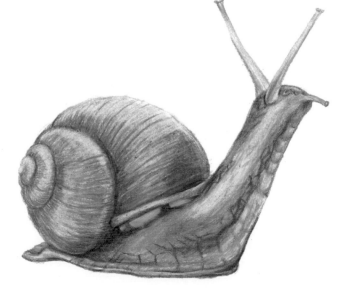

7 Erase some areas to create highlights. The eraser will help tighten and blend tones at the same time. Add back any lines that define form if they were erased.

TARANTULA

Puppies and kittens aren't the only fuzzy critters! Hatching is a great technique for drawing furry textures on any kind of object or animal, including this tarantula.

BASIC SHAPES

1 Start with a large circle for the abdomen, a medium-sized circle for the head/thorax, and a small circle for the jaws.

2 Add lines as guides for the eight legs and two antennae.

3 Thicken the legs by drawing around the leg guidelines.

Guideline not necessarily in center of leg.

FUN FACT

The antennae are technically known as "pedipalps" and look like smaller versions of the spider's legs.

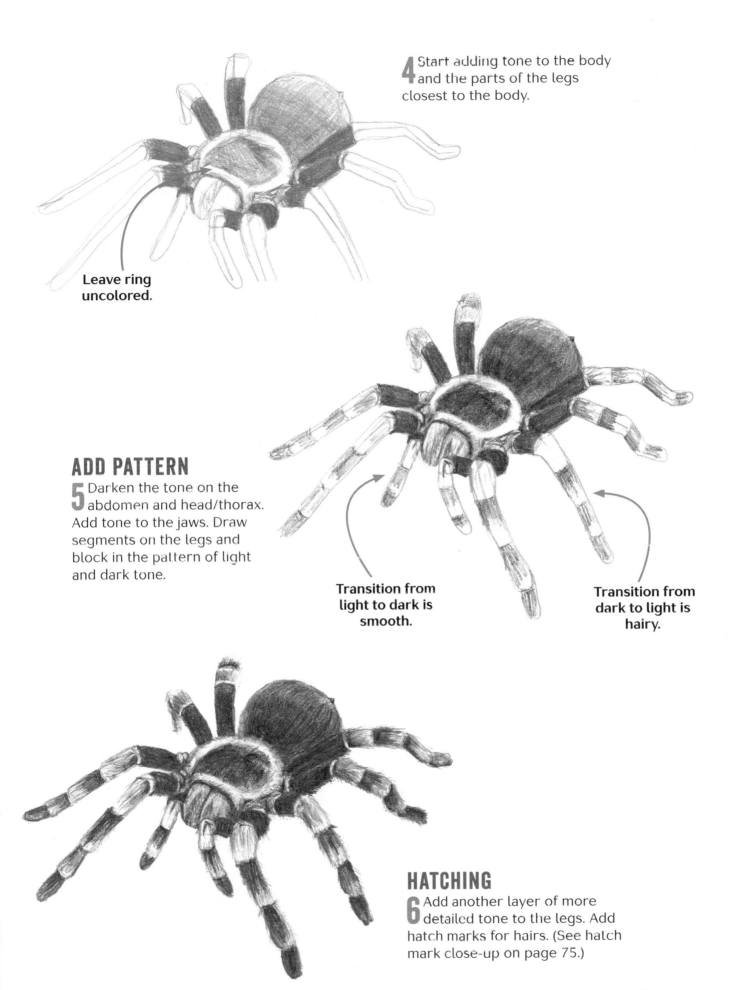

4 Start adding tone to the body and the parts of the legs closest to the body.

Leave ring uncolored.

ADD PATTERN

5 Darken the tone on the abdomen and head/thorax. Add tone to the jaws. Draw segments on the legs and block in the pattern of light and dark tone.

Transition from light to dark is smooth.

Transition from dark to light is hairy.

HATCHING

6 Add another layer of more detailed tone to the legs. Add hatch marks for hairs. (See hatch mark close-up on page 75.)

ANOLE

In this tutorial, we'll use a few different patterns to capture the pebbly texture of the anole's skin. This technique works well for many other types of lizards too.

1 Start with a small circle for the head. Draw a guideline indicating the position and length of the body and tail.

BASIC OUTLINE

2 Add a rounded triangle for the snout and an oval for the body. Trace a line around the remainder of the guideline for the tail.

Bump for left eye

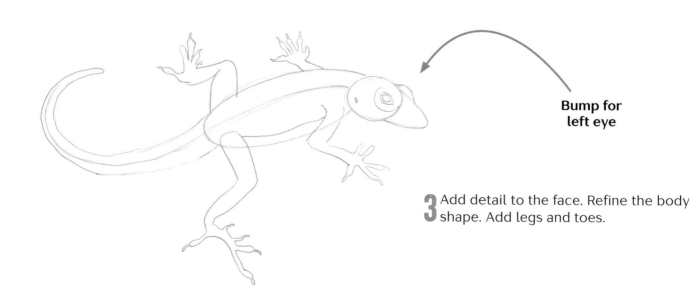

3 Add detail to the face. Refine the body shape. Add legs and toes.

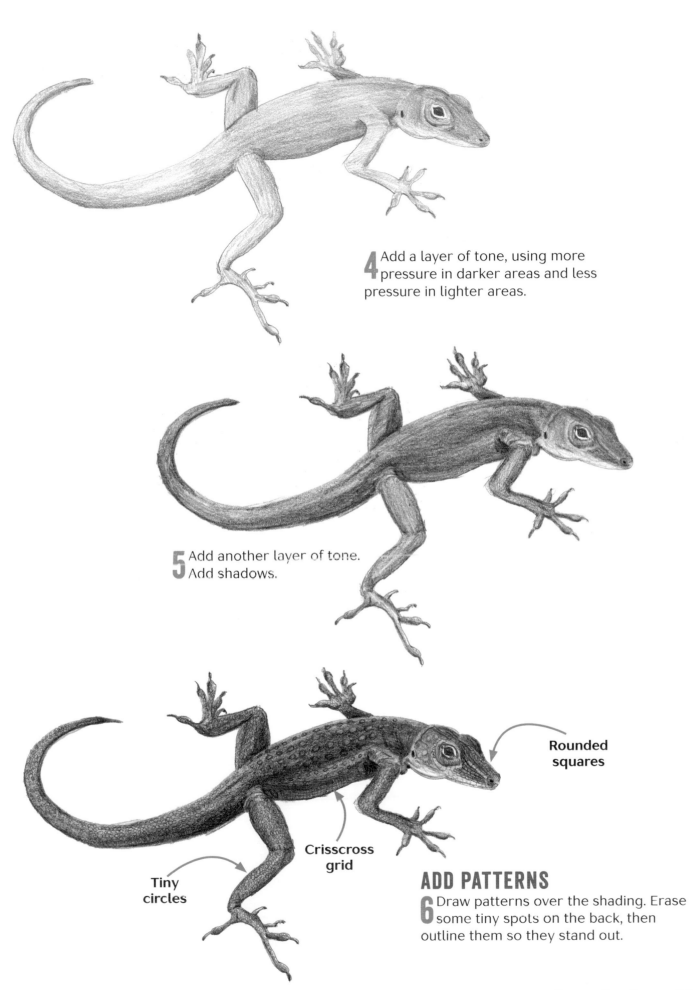

4 Add a layer of tone, using more pressure in darker areas and less pressure in lighter areas.

5 Add another layer of tone. Add shadows.

Rounded squares

Crisscross grid

Tiny circles

ADD PATTERNS
6 Draw patterns over the shading. Erase some tiny spots on the back, then outline them so they stand out.

BULLET ANT

The bullet ant is a South American insect named after its excruciatingly painful sting. Appropriately enough, we'll use a sharp tool like a needle or pin to create the ant's tiny hairs.

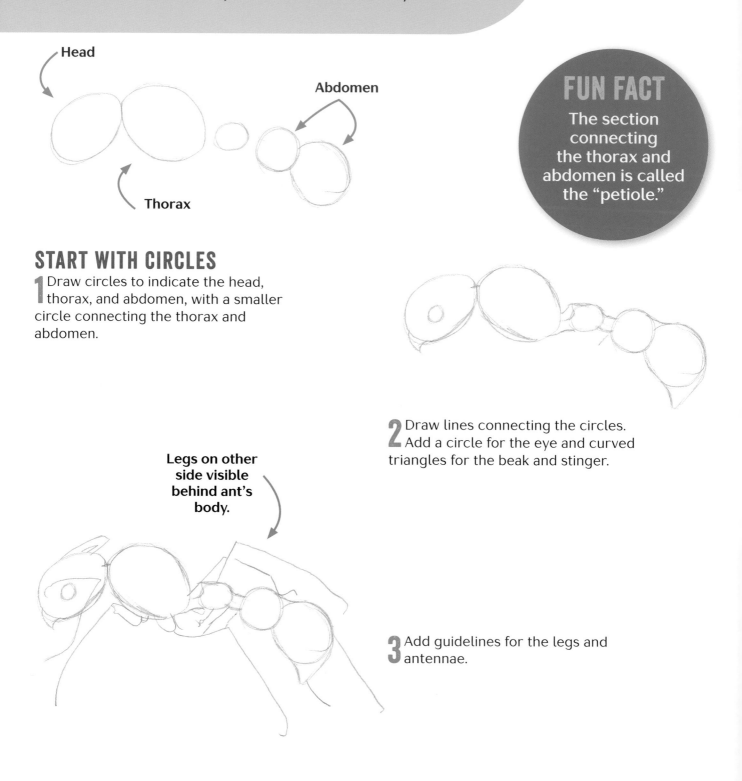

Head

Abdomen

Thorax

FUN FACT

The section connecting the thorax and abdomen is called the "petiole."

START WITH CIRCLES

1 Draw circles to indicate the head, thorax, and abdomen, with a smaller circle connecting the thorax and abdomen.

2 Draw lines connecting the circles. Add a circle for the eye and curved triangles for the beak and stinger.

Legs on other side visible behind ant's body.

3 Add guidelines for the legs and antennae.

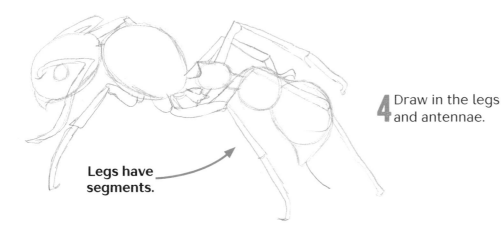

**Legs have
segments.**

4 Draw in the legs
and antennae.

NEEDLE SCRATCH

5 Before adding tone, use a small,
sharp tool such as a pin or paper clip
to "draw" a few hairs along the cross
contours of the body and legs. These will
appear white after you add tone over
them (see page 24 for a close-up). Add a
layer of tone to block out different areas
of the ant.

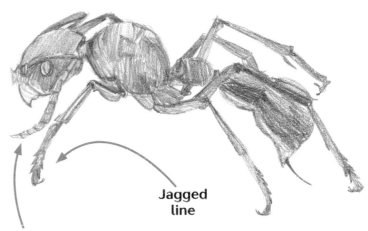

**Jagged
line**

**Antennae
have
segments.**

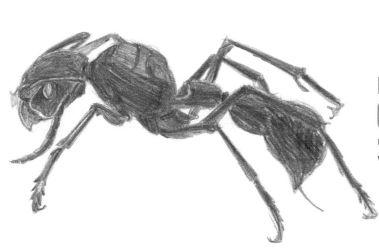

DARKEN TONE

6 Add a darker layer of tone to create
more contrast, leaving lighter areas
untouched. The white needle scratches
will become more visible.

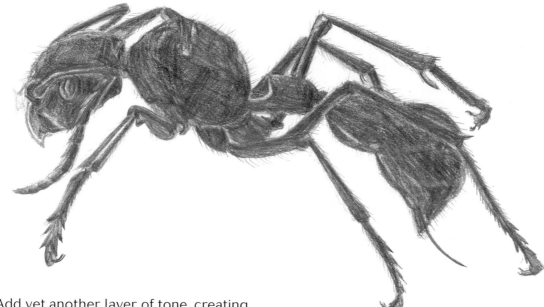

7 Add yet another layer of tone, creating lots of contrast between the ant and the background. Add short hatch marks for hairs coming from the legs and body.

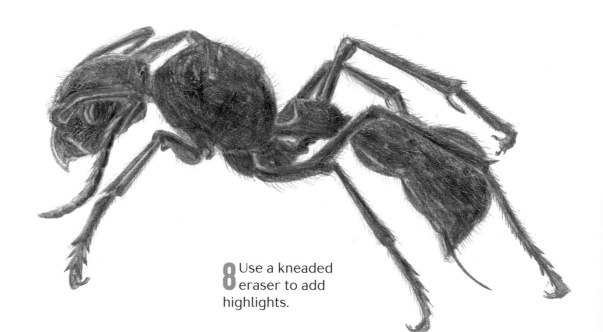

8 Use a kneaded eraser to add highlights.

FROG

By strategically adding highlights with an eraser, you can create the illusion that this pencil drawing of a frog is wet and shiny.

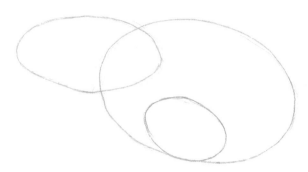

1 Start with an oval for the head, a circle for the body, and a small oval for the front leg.

2 Add circles for the eyes, a curved line for the throat, and ovals for the back legs.

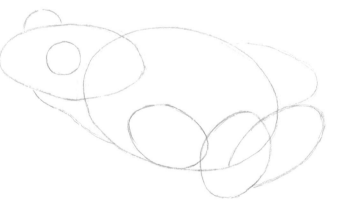

BASIC OUTLINE
3 Finish the legs with feet.

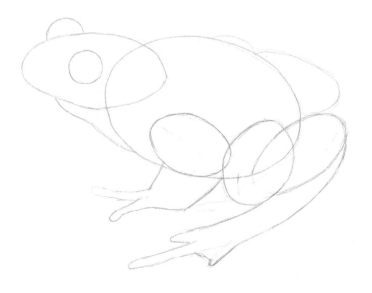

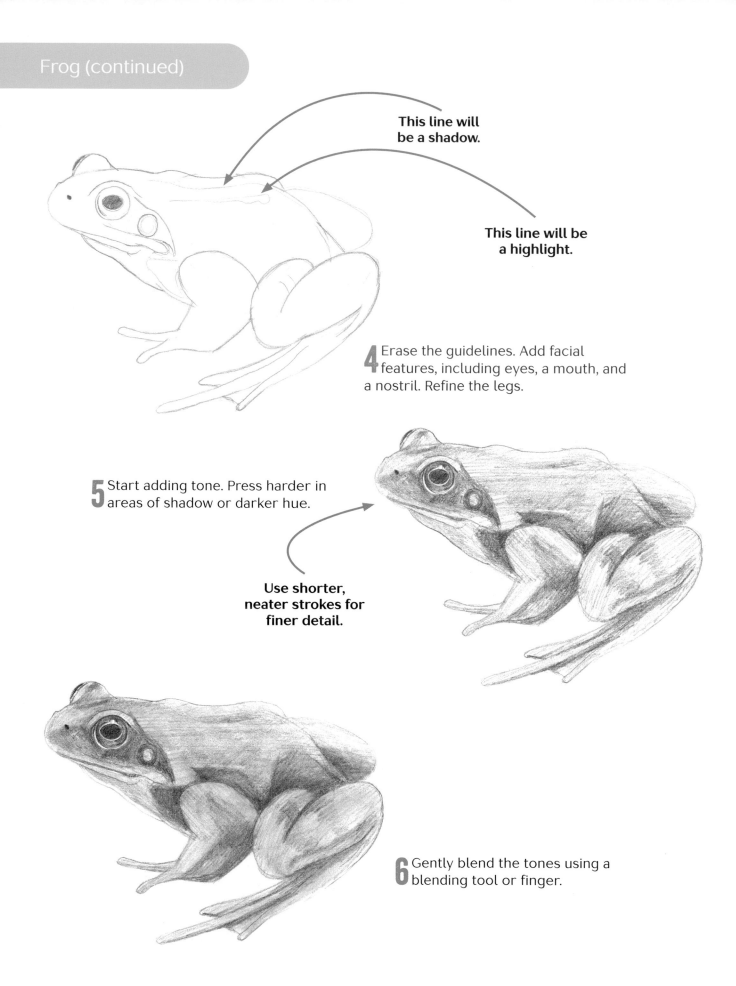

This line will be a shadow.

This line will be a highlight.

4 Erase the guidelines. Add facial features, including eyes, a mouth, and a nostril. Refine the legs.

5 Start adding tone. Press harder in areas of shadow or darker hue.

Use shorter, neater strokes for finer detail.

6 Gently blend the tones using a blending tool or finger.

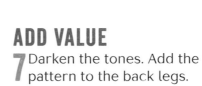

ADD VALUE

7 Darken the tones. Add the pattern to the back legs.

QUICK TIP

I used both a kneaded eraser and an eraser stick when making these highlights.

ERASE HIGHLIGHTS

8 Erase areas of shine and outline them a bit on some sides so they really stand out. Add dark patches for spots on the legs and throat.

Highlights follow cross contours.

BLUE TRIANGLE BUTTERFLY

Sharpies or other permanent markers do a great job of capturing the electric colors of Australia's blue triangle butterfly. If you use water-based markers instead, make sure to add the black last, to prevent the colors from bleeding.

MARKER

START WITH PENCIL

1 Start with two rounded triangles for the upper halves of the wings, two for the lower halves, and an oval body in the center.

Less defined scallop shapes

2 Refine the shape of the wings and the body. Add antennae.

More defined scallop shapes

Each shape has a reflected partner on the other wing.

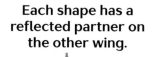

3 Erase the guidelines. Draw the pattern on the wings. Try to make it as symmetrical as possible. Refine the head area further.

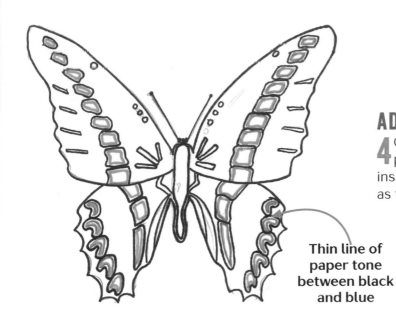

ADD MARKER

4 Outline the shapes in the pattern with permanent black marker. Rim the insides with a lighter shade of blue, such as teal.

Thin line of paper tone between black and blue

START COLORING

5 Color in the blue spots with a light blue marker. Add some gray and dark blue lines for striations in the wing.

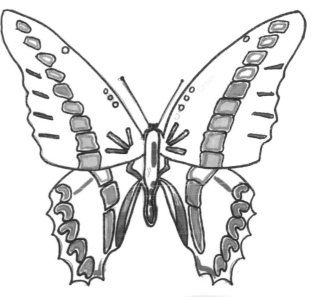

Leave white for highlight.

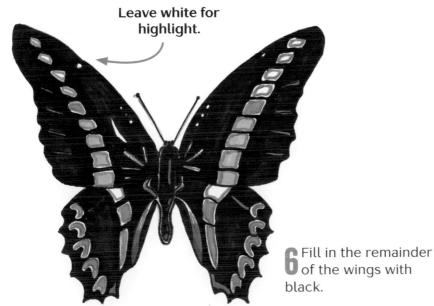

6 Fill in the remainder of the wings with black.

QUICK TIP

For more accuracy, use an ultrafine-point black marker to outline the blue spots. Then continue coloring in the black with your regular marker.

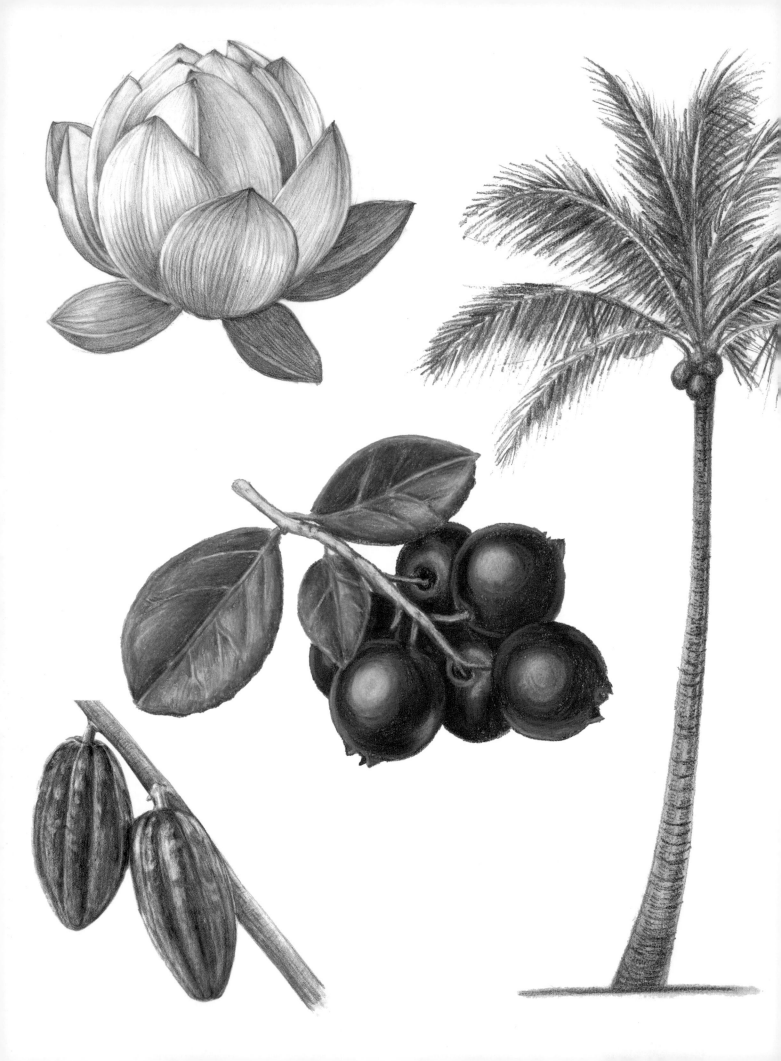

Chapter 5
FANTASTIC FLORA

The natural world is teeming with animals, but it's also full of plants! In this chapter, we'll draw flowers, trees, and more from all over the world. Some of them are delicious (like the lingonberry and the cacao bean), some are beautiful (like the lotus and the bird of paradise), and others are just plain fascinating (like the baobab tree).

BAOBAB TREE

The iconic African baobab tree uses its large, bulbous trunk to store water, which it can draw on in times of drought. We'll use cross contouring to map the curve of the trunk and scumbling to capture the texture of the leaves.

1 Start with two long lines for the trunk with Y shapes at the top for branches.

2 Add more lines to indicate sharply crooked branches.

Light source is here.

ADD TONE

3 Add some thin, cloud-like shapes to the top to block in the tree's leaves. Add a layer of tone over the whole tree, pressing harder in areas of shadow, lighter in illuminated areas.

BLEND

4 Smooth the tones with a blending tool.

5 Press with a kneaded eraser to lighten any highlighted areas that were darkened by the blending step. Draw light lines on the trunk and branches, following the tree's cross contours. Press harder in areas of shadow.

Use kneaded eraser to highlight.

Lightly erase outline around leaves.

SCUMBLE

6 Add scumbling to the leaves (see page 27 for more info on scumbling). Press harder in areas of shadow, lighter in areas of highlight.

QUICK TIP

Following the cross contours of the trunk helps define the form and add texture. They look like lines wrapping around the shape.

Reflected light on left side of trunk

7 Darken areas of shadow on the tree and its leaves. Use an eraser to add highlights and clean up the edges. Blend with a blending tool and clean up any side smudges. Draw some branches peeking through the leaves.

UMBRELLA THORN ACACIA

The umbrella thorn acacia is another icon of the African savanna. It gives us an opportunity to practice the scumbling technique we started in the baobab tutorial.

1 Start with a lean trunk that branches out into a wide V shape. Add curves on top, resembling an umbrella, for the leaves.

2 Add some thin branches inside the V. Add more curves at the top to form a block of leaves.

Branches get leaner and denser toward top.

BASIC OUTLINE

3 Add curves to block in bunches of leaves that are in shadow or highlight. Add more branches.

4 Add a layer of tone over the whole tree, including the leaves. Use more pressure in areas of shadow.

ADD VALUE

5 Press harder in areas of darkness to add texture and depth. Add some smaller branches near the treetop.

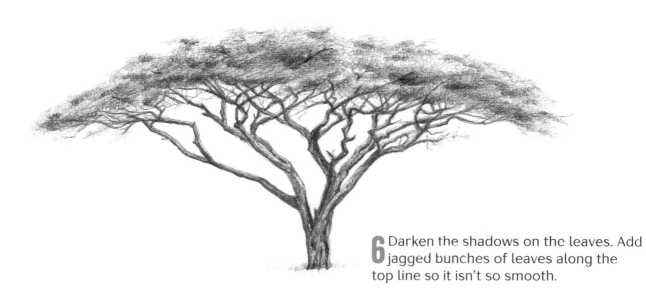

6 Darken the shadows on the leaves. Add jagged bunches of leaves along the top line so it isn't so smooth.

CACAO

Native to South and Central America, the cacao bean is the plant that gives us chocolate. Each of the pods you'll draw in this tutorial contains 30 to 50 beans.

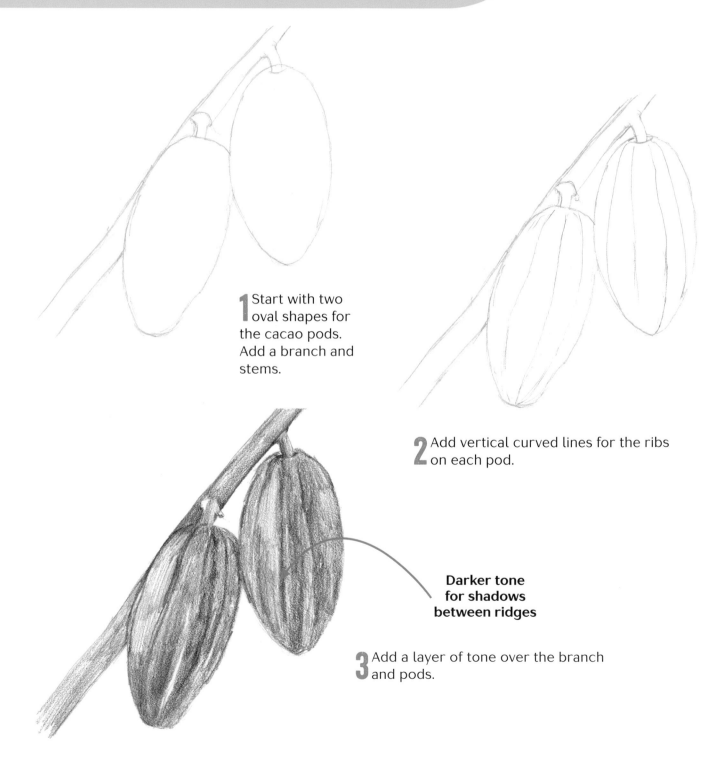

1 Start with two oval shapes for the cacao pods. Add a branch and stems.

2 Add vertical curved lines for the ribs on each pod.

Darker tone for shadows between ridges

3 Add a layer of tone over the branch and pods.

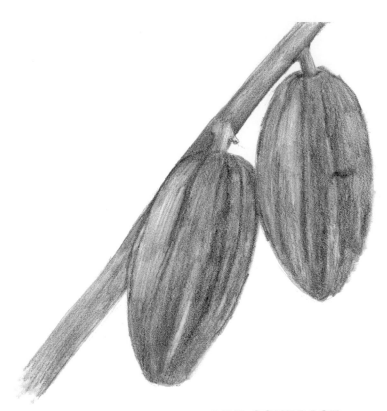

4 Blend the tones with a blending tool.

ADD CONTRAST
5 Add more tone to darken the core shadows and create more contrast.

Cross-contour lines on branch show depth.

6 Use a kneaded eraser to add highlights. Deepen tones even more to create even more contrast.

LINGONBERRY

COLORED PENCIL

Lingonberries grow wild in countries like Sweden (you may have had lingonberry jam with Swedish meatballs). You can use the techniques you learn in this project to draw other berries you may find closer to home, like blueberries.

Circles overlap.

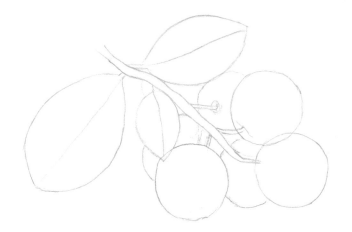

1 Start with a few circles around the same size. Draw a line coming from one that will be a branch.

BASIC OUTLINE

2 Add more circles behind the ones from step 1, so that the circles in back are partially obscured. Add a branch, stems, and leaves.

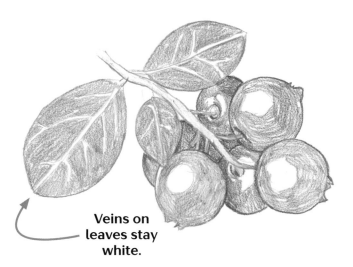

Veins on leaves stay white.

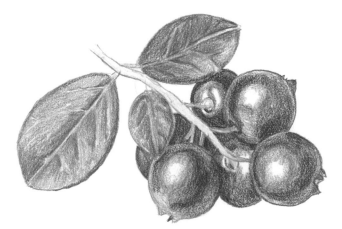

ADD COLOR

3 Add a layer of color: simple green for the leaves, yellow-tan for the branch, and red for the berries. Don't press too hard with the pencils. Leave a white spot on the berries for the highlight.

4 Add deeper red tones in areas of shadow. Add orange tones around the highlights. Use dark green to rim the leaves and some veins. Add yellow ochre to the other veins.

Light umber for texture on stem

Indigo blue for darkest shadows on leaves

5 Add dark purple over the deepest shadows and blend it out toward the light with lighter pressure. Add more deep red and bright red to smooth the color transition. Fill in the highlight with a light layer of red.

QUICK TIP

Make the veins on the leaves leaner by using a deep green pencil sharpened to a fine point to define them more.

6 Fill in the dark sides of the leaves with olive green, blending it with the indigo. Use beige to go over the veins and any areas on the leaves that have paper tone showing. Warm up shadows on the berries with brown tones. Use white to smooth out highlights and reflected light.

Add gray to edge of branch.

Highlight

Reflected light

FINISHING TOUCHES

7 If necessary, use a kneaded eraser to lighten highlights, then add more white pencil on top to lighten them further. Add brown hatch marks and deep brown to the branch and stems for shadow and texture. Add a bit of green to the stem.

LOTUS

This partially bloomed lotus provides a great lesson for drawing the shape and texture of flower petals.

Rounder toward base, pointier toward top

A SIMPLE GUIDELINE

1 Start with a circle as a guideline for the flower.

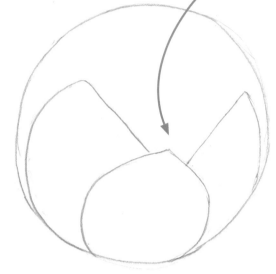

2 Start to add petals. Use the side of the original circle as part of the petals.

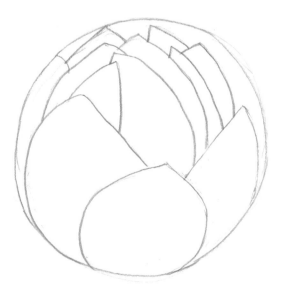

3 Add more petals. They get smaller and overlap more toward the top of the circle.

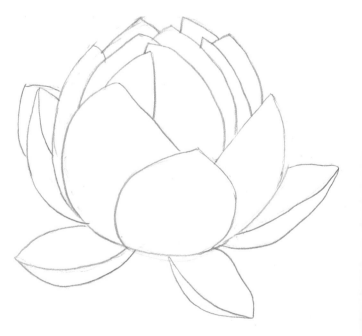

4 Add a few petals outside the circle. Erase the top part of the original guideline circle.

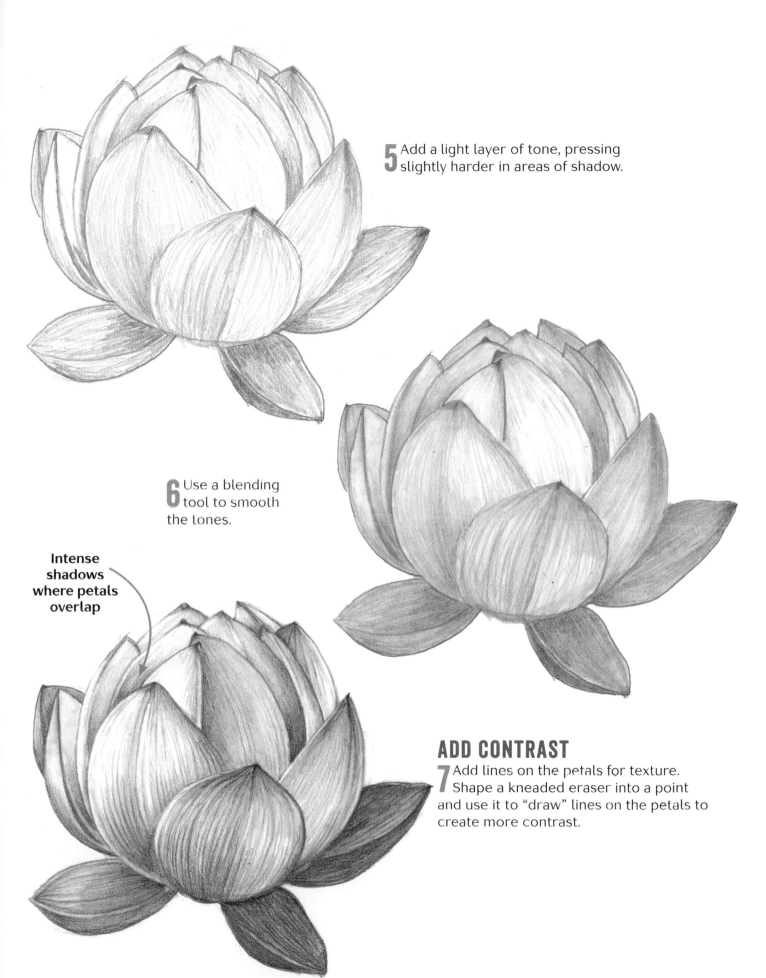

5 Add a light layer of tone, pressing slightly harder in areas of shadow.

6 Use a blending tool to smooth the tones.

Intense shadows where petals overlap

ADD CONTRAST

7 Add lines on the petals for texture. Shape a kneaded eraser into a point and use it to "draw" lines on the petals to create more contrast.

COCONUT PALM

What do you need to recreate the palm leaves on this tropical tree? A little bit of patience and a lot of gently curved lines.

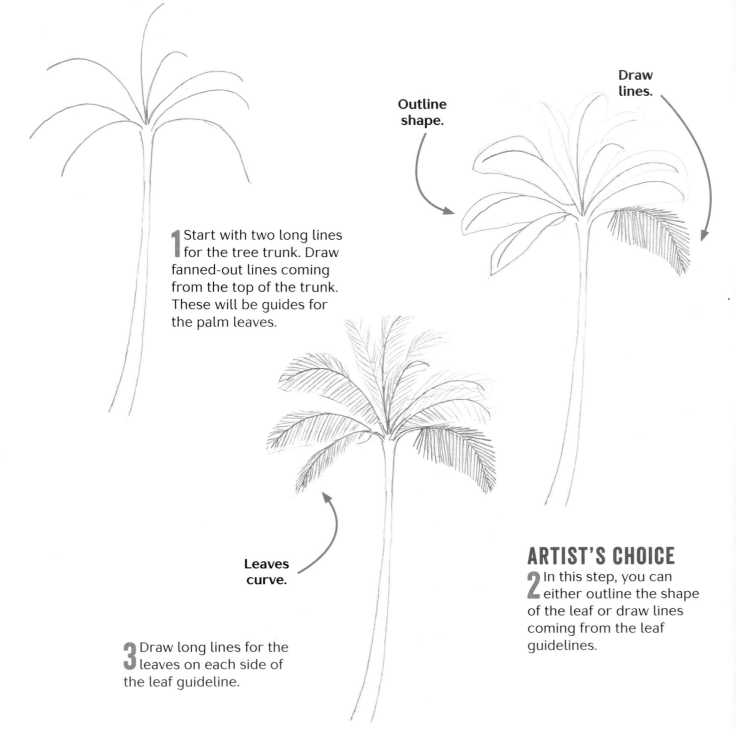

1 Start with two long lines for the tree trunk. Draw fanned-out lines coming from the top of the trunk. These will be guides for the palm leaves.

Outline shape.

Draw lines.

Leaves curve.

3 Draw long lines for the leaves on each side of the leaf guideline.

ARTIST'S CHOICE
2 In this step, you can either outline the shape of the leaf or draw lines coming from the leaf guidelines.

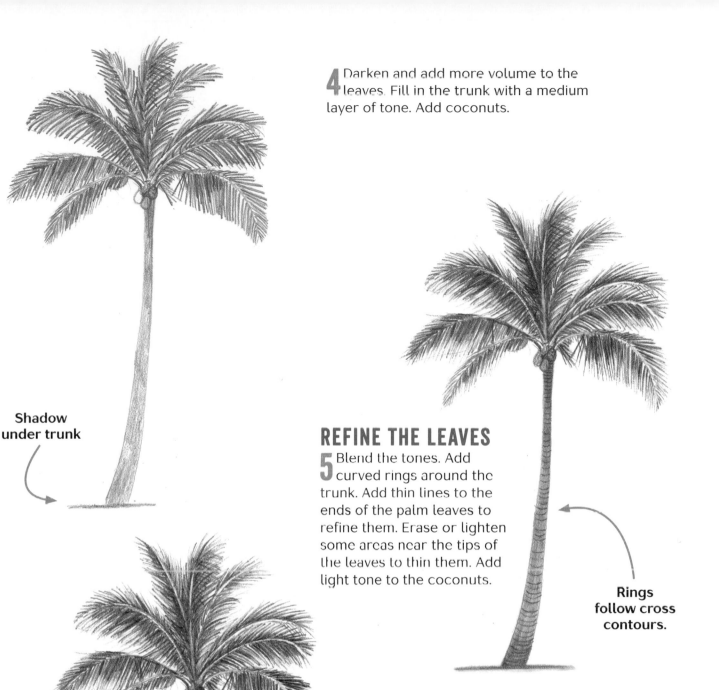

4 Darken and add more volume to the leaves. Fill in the trunk with a medium layer of tone. Add coconuts.

Shadow under trunk

REFINE THE LEAVES
5 Blend the tones. Add curved rings around the trunk. Add thin lines to the ends of the palm leaves to refine them. Erase or lighten some areas near the tips of the leaves to thin them. Add light tone to the coconuts.

Rings follow cross contours.

6 Add some more dark areas where the individual leaves meet the branch. Shade the coconuts. Add hatch marks to the trunk for more texture and contrast.

BIRD OF PARADISE

If you've never drawn with watercolor pencils, this bird of paradise is a lovely and colorful way to try them out. Use watercolor paper or another thick paper, because you'll be adding water to activate the colors in the last step.

WATER-
COLOR
PENCIL

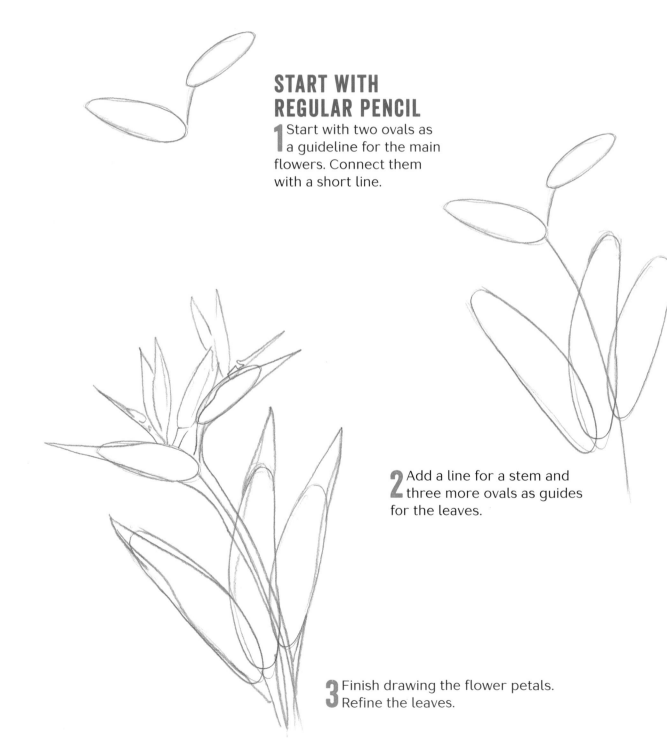

START WITH REGULAR PENCIL

1 Start with two ovals as a guideline for the main flowers. Connect them with a short line.

2 Add a line for a stem and three more ovals as guides for the leaves.

3 Finish drawing the flower petals. Refine the leaves.

ADD COLOR

4 Erase guidelines. Use an eraser to lighten all the lines so the sketch-pencil tone interferes with the color less. Using watercolor pencils (I like Sargent), start to outline and fill in the plant with a light layer of basic tones: red, orange, yellow, green, and blue for the flower, and shades of green and yellow for the leaves and stem.

Green on top of red for subtle shadow

Red on leaf tips

5 Add a bit of purple to the blue. Darken the blue. Press harder with another layer of orange and yellow on the flowers. Darken the stems with more green and yellow. Add a bit of black to blend the darkest areas.

QUICK TIP

Be sure to clean your brush frequently and don't blend the colors much. Otherwise the red and green will combine to turn your colorful flower brown!

ADD WATER

6 Dip a small paintbrush in a clean cup of water, wiping the excess off on the edge of the cup. Gently swipe wetness over the colored pencil one area at a time. The colors should appear slightly more blended, bright, and vibrant.

EUCALYPTUS

There are more than 700 species of eucalyptus tree, most found only in Australia. Here we'll draw the branches of a species with round, flat leaves.

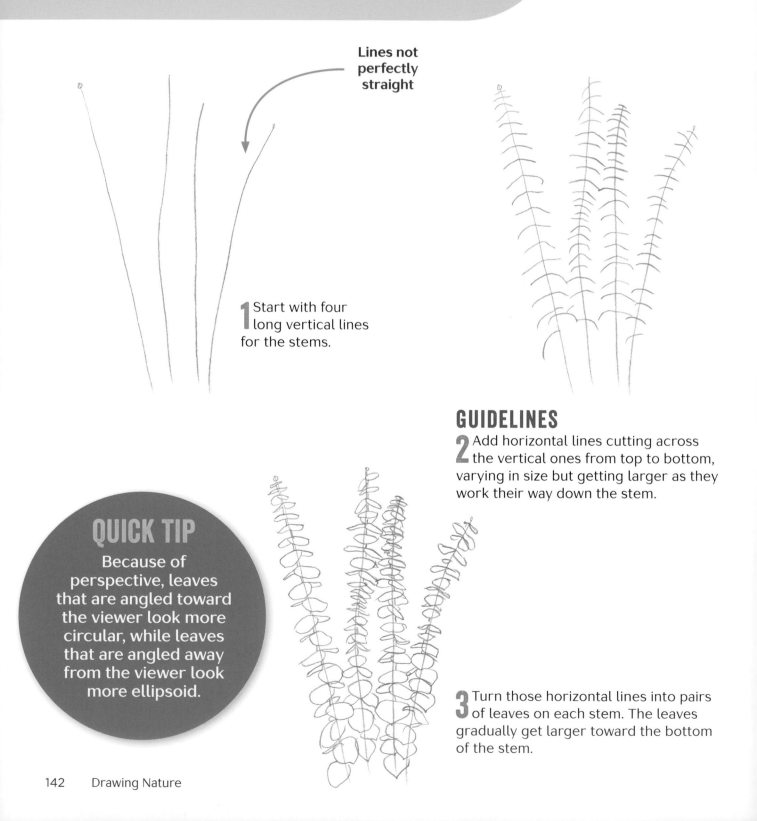

Lines not perfectly straight

1 Start with four long vertical lines for the stems.

GUIDELINES
2 Add horizontal lines cutting across the vertical ones from top to bottom, varying in size but getting larger as they work their way down the stem.

QUICK TIP
Because of perspective, leaves that are angled toward the viewer look more circular, while leaves that are angled away from the viewer look more ellipsoid.

3 Turn those horizontal lines into pairs of leaves on each stem. The leaves gradually get larger toward the bottom of the stem.

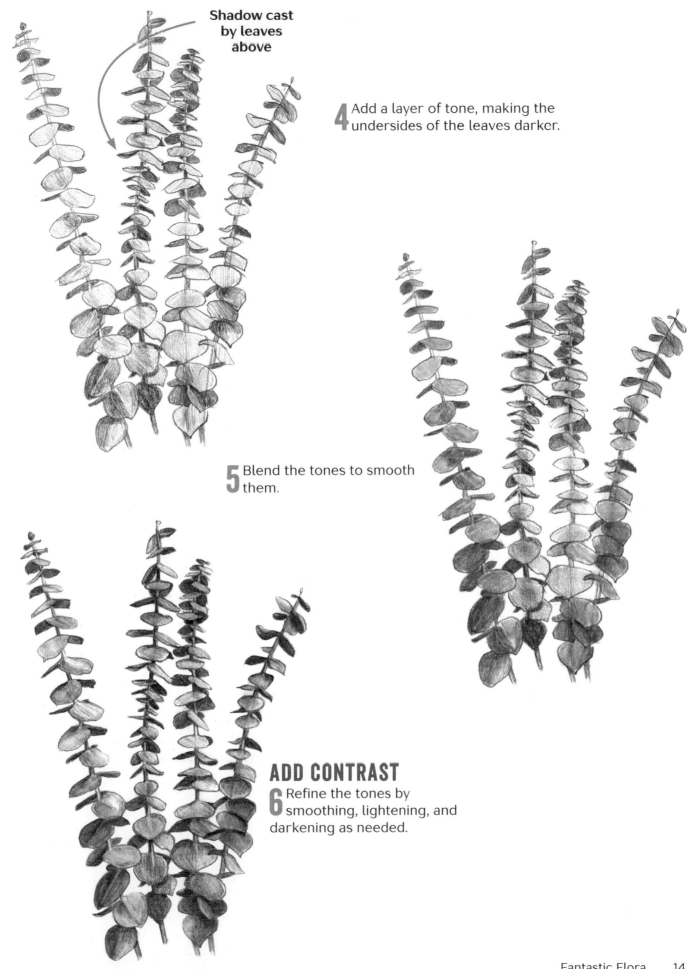

Shadow cast by leaves above

4 Add a layer of tone, making the undersides of the leaves darker.

5 Blend the tones to smooth them.

ADD CONTRAST

6 Refine the tones by smoothing, lightening, and darkening as needed.

KELP

Scientifically speaking, kelp is an algae, not a plant. Artistically speaking, kelp is fun and easy to draw! Keep this tutorial in mind next time you sketch a beach scene.

1 To draw the floats, start with a string of circles that get progressively smaller. Add a guideline for a leaf and stem.

FUN FACT

Technically, the floats are called "pneumatocysts," the leaves "blades," and the stems "stipes."

BASIC OUTLINE

2 Draw lines flowing in the same direction for the leaves. Connect the floats to the stem.

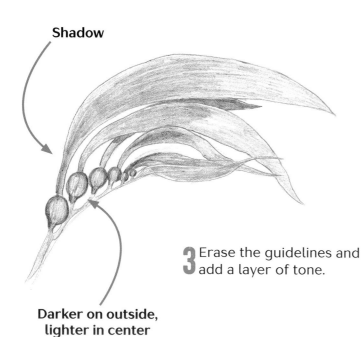

Shadow

3 Erase the guidelines and add a layer of tone.

Darker on outside, lighter in center

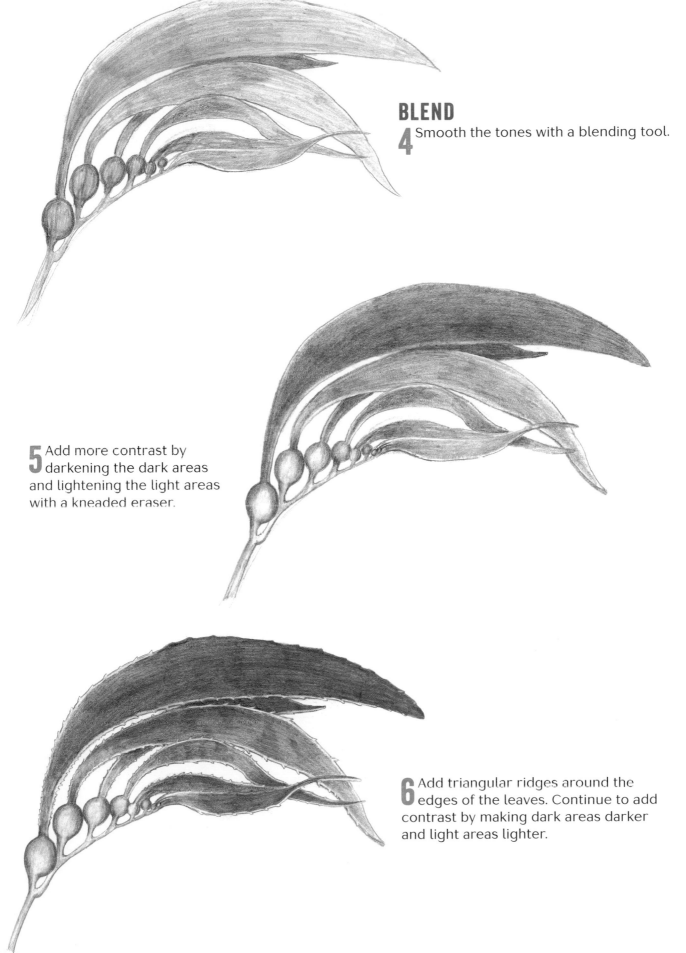

BLEND

4 Smooth the tones with a blending tool.

5 Add more contrast by darkening the dark areas and lightening the light areas with a kneaded eraser.

6 Add triangular ridges around the edges of the leaves. Continue to add contrast by making dark areas darker and light areas lighter.

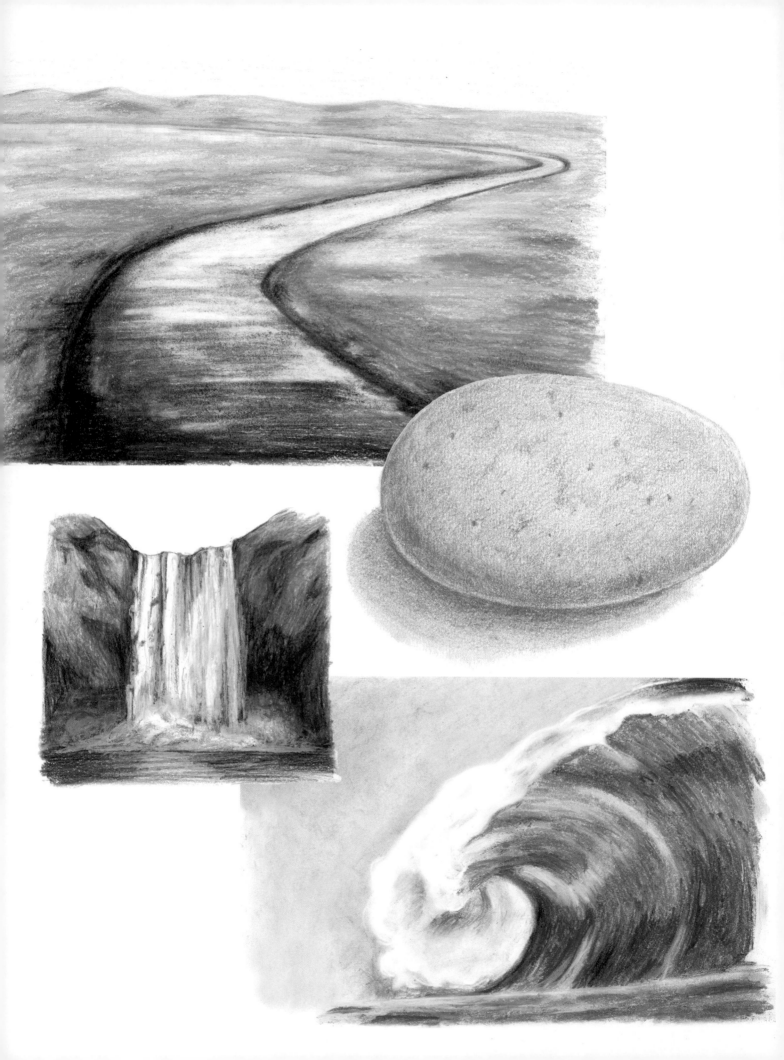

Chapter 6
LOVELY LANDSCAPES

So far, we've covered how to draw living things in nature: plants and animals. But a big part of drawing nature is drawing the nonliving elements like rocks, rivers, and waves. That's what we'll cover in this chapter, using a variety of artistic media such as crayon and chalk pastel.

WATERING HOLE

Watering holes provide hydration for thirsty animals on the African savanna. As you draw this one, think about how you can use the contrast between colors to create realistic ripples.

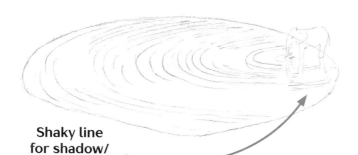

Shaky line for shadow/ reflection

START WITH PENCIL

1 Lightly draw an oval shape for the outer edge of the watering hole. Draw curved lines for ripples. Add an animal if you want; I used an elephant.

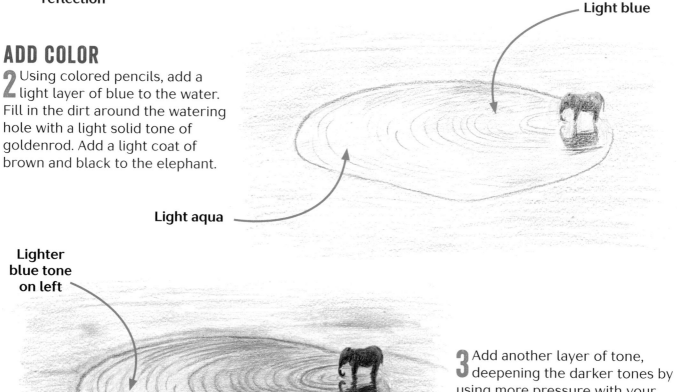

Light blue

ADD COLOR

2 Using colored pencils, add a light layer of blue to the water. Fill in the dirt around the watering hole with a light solid tone of goldenrod. Add a light coat of brown and black to the elephant.

Light aqua

Lighter blue tone on left

3 Add another layer of tone, deepening the darker tones by using more pressure with your pencil. Blend the dirt with white or light tones to remove the paper tone underneath. Go over the ripples and the elephant's shadow with blue, pressing harder. Darken the elephant.

Darker blue tone on right

Blue inner rim

BLEND WITH COLOR

4 Darken the water more to blend out any paper tone. Use a peachy tone to do the same with the dirt. Smooth the tone with a yellow ochre.

Brown outer rim

QUICK TIP
Use the side of the pencil tip rather than the point to make the tone smoother and fill the area in quicker.

ERASE

5 Use a rubber eraser to erase some of the blue in the water in the shape of ripples. Erase some areas in the dirt to make it lighter.

6 Darken the elephant's shadow. Use an eraser to "draw" tusks. Add medium-blue tones next to the light ripples in the water. Darken the brown and blue rims around the watering hole.

Deep blue shadow lines

ROCKS

If you want to draw nature scenes, you'll need to know how to draw rocks. The key is to pay attention to where the light source is and how it causes the rough edges of the rock face to cast shadows.

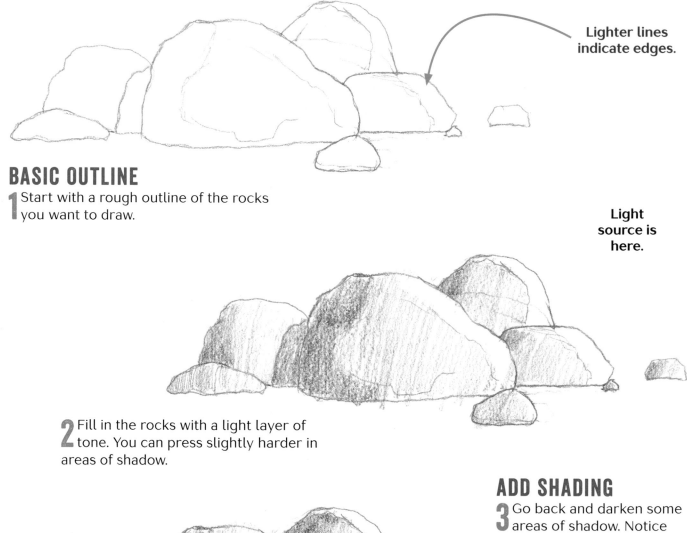

Lighter lines indicate edges.

Light source is here.

BASIC OUTLINE

1 Start with a rough outline of the rocks you want to draw.

2 Fill in the rocks with a light layer of tone. You can press slightly harder in areas of shadow.

ADD SHADING

3 Go back and darken some areas of shadow. Notice the shadows are darkest on the opposite side of the light source.

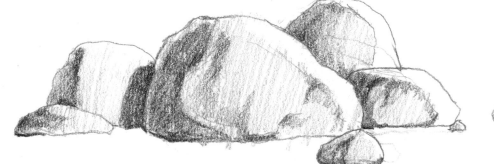

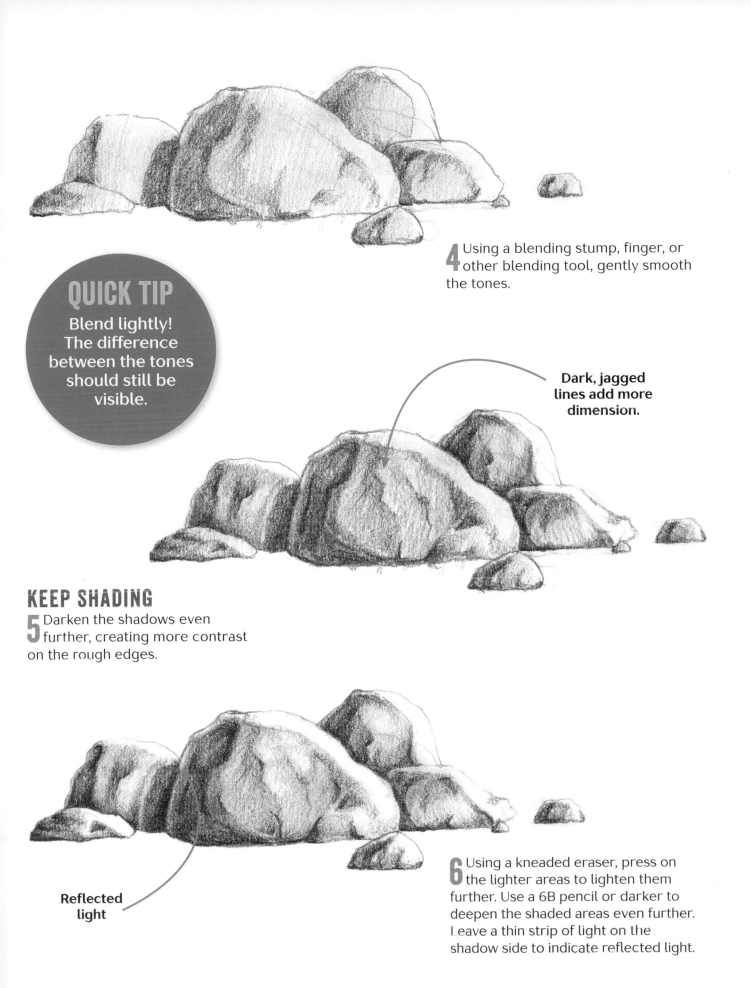

4 Using a blending stump, finger, or other blending tool, gently smooth the tones.

QUICK TIP

Blend lightly! The difference between the tones should still be visible.

Dark, jagged lines add more dimension.

KEEP SHADING

5 Darken the shadows even further, creating more contrast on the rough edges.

Reflected light

6 Using a kneaded eraser, press on the lighter areas to lighten them further. Use a 6B pencil or darker to deepen the shaded areas even further. Leave a thin strip of light on the shadow side to indicate reflected light.

RIVERBEND

Because of the way perspective works, things that are farther away appear smaller. In this tutorial, the curves of the river gradually shrink into the distance. Note the role color plays in conveying this effect.

Almost no space between lines

1 Start with a simple curvy guideline that stretches across the top of the page and works its way down toward the center.

THE ILLUSION OF PERSPECTIVE

2 Draw a line on either side of the guideline, following its contour. The space between the lines is wider near the bottom of the page (closer to the viewer), narrower near the top (farther from the viewer).

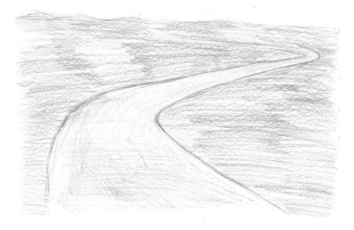

3 Erase the guideline. Add a wavy horizon line separating the sky from the ground.

SIMPLE COLORS

4 Add a light layer of color: blue for the water, green for the grass, light blue for the sky.

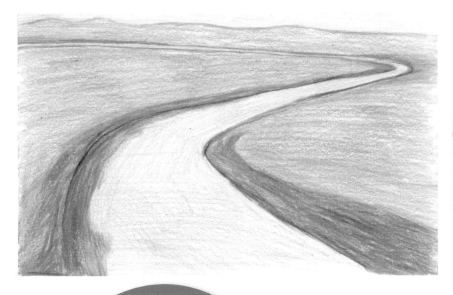

5 Add another layer of color, starting to add dimension. Use darker blue for the water closest to the riverbanks and darker green for the grass closest to the water. Layer the colors.

QUICK TIP

Colors are darker and more intense the closer they are, and lighter as they move up the paper and appear to be more in the distance.

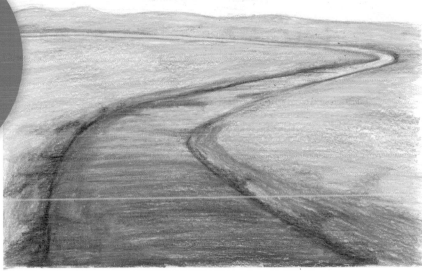

DEEPEN TONES

6 Use darker blues and greens for the water and grass closest to the bottom of the paper. Layer the tones for depth and variety.

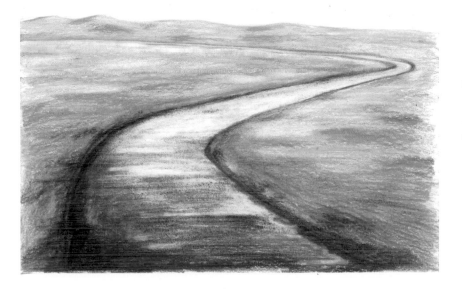

7 Add deeper tones for shadows on the water and grass. Use an eraser to highlight areas on the water and grass.

STONE

There are rough-edged rocks like the ones on page 150, and then there are the smooth stones you find on beaches or near rivers. Well-chosen shading will make your stone look solid and three-dimensional.

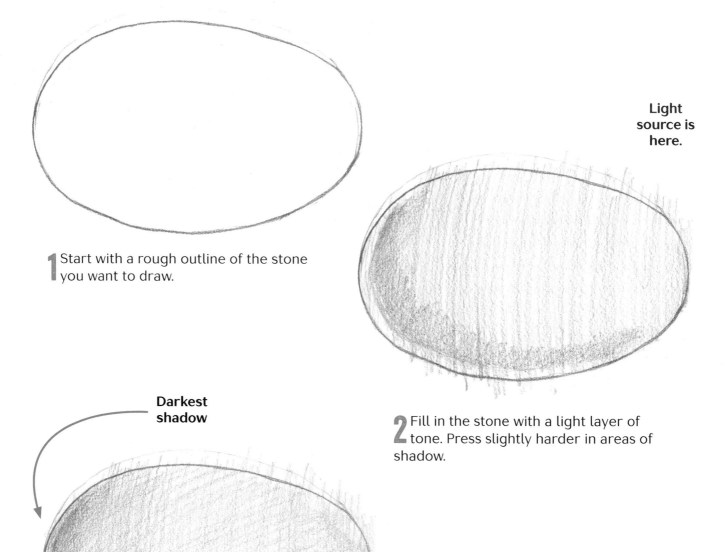

1 Start with a rough outline of the stone you want to draw.

Light source is here.

2 Fill in the stone with a light layer of tone. Press slightly harder in areas of shadow.

Darkest shadow

SHADE

3 Go back and darken some of the shadow areas. Notice the light source in the example is coming from the right, causing deeper areas of tone on the left.

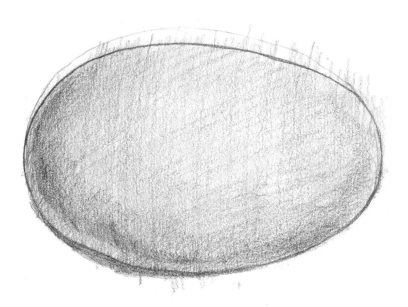

BLEND

4 Using a blending stump, finger, or other blending tool, gently smooth the tones, being careful not to blend it all into one undifferentiated gray.

5 Using the side of the pencil tip rather than the point, darken the areas of shadow even further, following the contour of the stone.

QUICK TIP

Use a 6B pencil or darker to shade the darkest areas even further.

FINISHING TOUCHES

6 Clean up the outer edges with an eraser. Press on the lighter areas with a kneaded eraser to lighten them further. Add small dots with the pencil point to indicate texture. Add a shadow on the ground.

Shadow is darkest directly under stone.

WATERFALL

Grown-ups can color with crayons too! Crayon isn't easy to blend, but it can still make beautiful art, as you'll see with this waterfall.

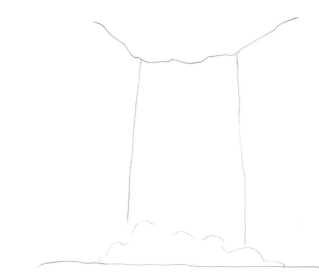

START SIMPLE

1 In pencil, outline the sides of the waterfall, the top of the cliff it's falling from, and the water below it. Add light curves for the mist where the waterfall hits the lake below.

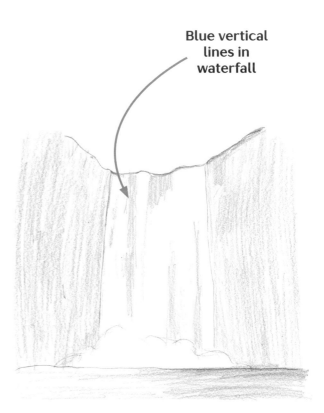

Blue vertical lines in waterfall

2 Add a light layer of crayon: blue for the water, green for the cliffside. Outline the mist in blue.

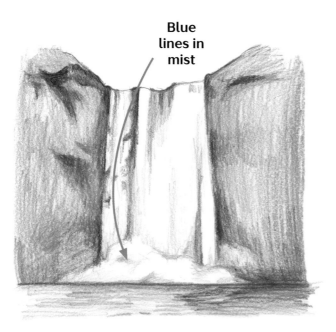

Blue lines in mist

ADD HUE

3 Add another layer of crayon. Use brown and black to define crags and areas of shadow. Deepen the blue in the vertical lines in the waterfall. Deepen the green on the cliffside.

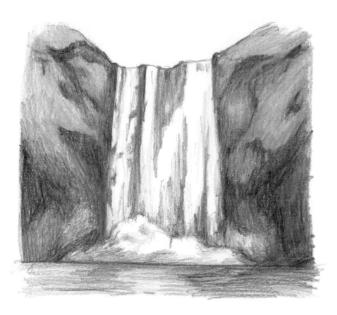

4 Add more shading to the cliff for texture. Add purple to the waterfall and the lake. Define the mist with light layers of blue and black tone.

5 Add blue to the shadows on the cliffs. Use black to add more definition. Add more vertical lines in cool shades to the waterfall.

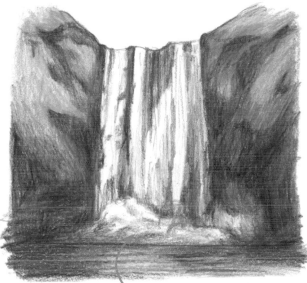

More blue and purple in lake and mist

QUICK TIP
Blending will be difficult, and some of the white will smear into other colors to soften them. Use this to your advantage!

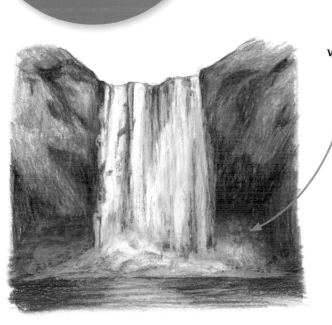

Add small white swirls for more mist.

DO YOUR BEST TO BLEND

6 Blend with heavy layers of white crayon (or white oil pastel if needed). Lighten some of the vertical lines on the waterfall. Add a warm yellowy-orange tone to the top of the cliff for more depth.

WAVE

Put down your pencils and pick up your chalk pastels to draw this awesome ocean wave. Use the side of the pastel when coloring large swatches of paper to get the job done faster.

QUICK TIP

If you feel more comfortable sketching the outline lightly in pencil first, go ahead.

Strokes follow curve of wave.

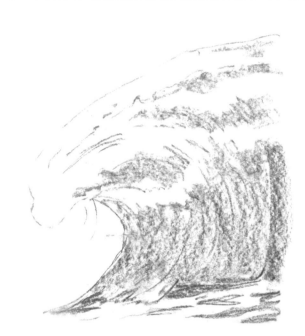

1 Sketch out the basic curve of the wave in blue chalk pastel, blocking in areas of color and leaving white untouched.

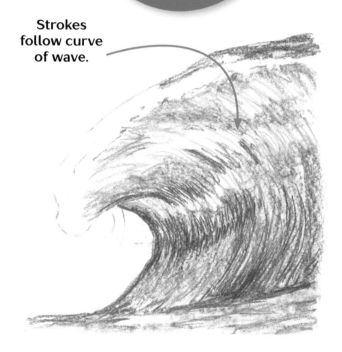

BLOCK IN COLORS

2 Add dark blue tones that follow the contour of the wave. Add touches of green and light blue to block in the shape.

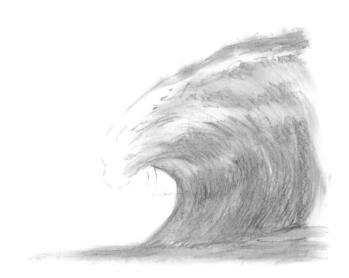

3 Blend with a chamois or other soft blending tool.

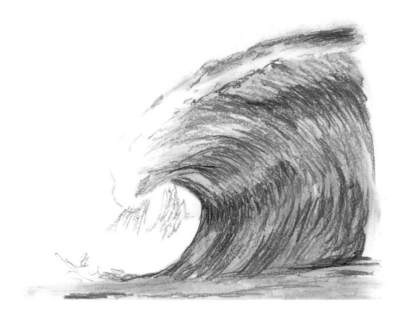

AN EXCEPTION TO THE OUTLINING RULE

4 Add another layer of hue, using navy and a touch of black in the darkest areas of the wave. Outline the foam a bit with blue. (Things aren't outlined in real life, but we need to define this white area a bit.)

5 Blend again. Add deep tones such as dark blue and even black to the darkest areas to make them more intense. Start to blend the white into any hard edges. Lightly shade in the background with blue to help eliminate any visible outlines.

Blend for soft mist effect.

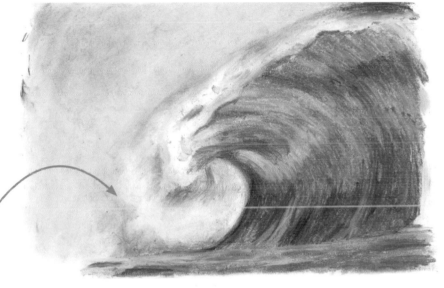

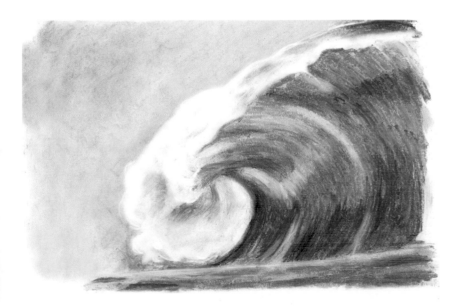

6 Add more white to the white areas. If they don't get white enough, sometimes an eraser can remove some pigment. Clean up the edges of the wave and lighten the foam.

Index

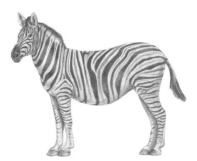